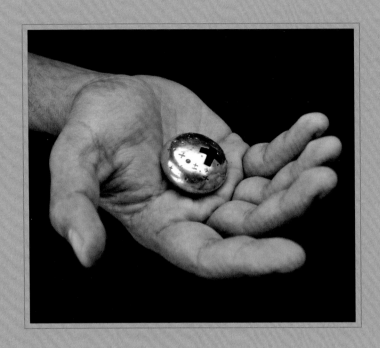

Old Traditions in New Pots

SILVER SEED POTS FROM THE
NORMAN L. SANDFIELD COLLECTION

TRICIA LOSCHER ■ HEARD MUSEUM
PHOENIX, ARIZONA

hm Heard Museum

2301 North Central Avenue
Phoenix, AZ 85004
602.252.8840
www.heard.org

© Heard Museum, 2007
ISBN 978-0-934351-79-9

Photography by Craig Smith
Coordinated by Kevin Coochwytewa
Designed by Lisa MacCollum
Edited by Carol Haralson
Printed in Canada

Unless otherwise cited, all comments from collector Norman L. Sandfield and from the artists included in this book are based on oral interviews conducted by the author in 2006 and 2007, or are excerpted from written communications supplied to the author and the Heard Museum. Direct quotes and essential information accompanying the pots in the catalogue to follow are from the same sources.

Artists represented in the collection were asked to participate by responding to a biographical questionnaire and answering questions about their pots. Some visited the museum and spoke with us about their works, the processes by which they were made, and the inspirations behind them. Thanks to Mr. Sandfield and to the makers of these beautiful artworks for their eloquence and generosity.

The hallmarks next to the artists' names are reproduced from the hallmarks on the pots in the Norman L. Sandfield Collection. Artists may change or alter their hallmarks throughout the course of their careers. Those pots in the collection that were not hallmarked are noted.

Norman L. Sandfield continues to collect seed pots even though he has gifted his collection to the Heard Museum. Thus, the 235 pieces represented in this book have grown to more than 250 in the Heard Museum's collection.

(cover images, clockwise from top left)
NORBERT PESHLAKAI, Navajo, b. 1953, HORSE I, 1999, Silver, coral. ■ TRADITION, 2006, Silver, Sleeping Beauty turquoise, coral. ■ POT, mid-1980s Silver, coral. ■ POT, 1992, Silver, coral, turquoise, shell, jet, mother-of-pearl, sugilite.

Contents

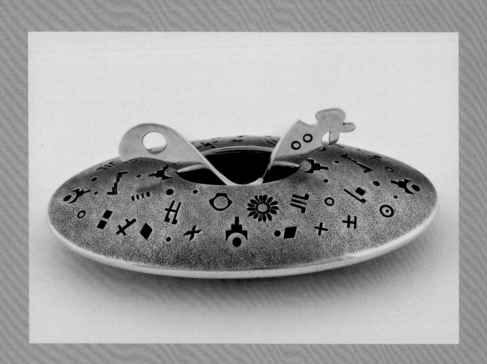

Director's Preface

THE MAKING OF SMALL, PRECIOUS OBJECTS has challenged the craftsman-artist throughout history. Whether the tradition of carved ivory *netsuke*, Fabergé eggs, painted portrait miniatures framed and worn as lockets, or the ubiquitous miniature dollhouses that populated nineteenth-century homes, a universal fascination with small, intricate, beautiful objects has existed.

This fascination captures the viewer of Norman L. Sandfield's collection of silver seed pots recently gifted to the Heard Museum. We are awed by the sheer variety that confronts us, by the complexity and elegant simplicity of the surface designs, and always by their extraordinary sophistication. These designs, emerging from the luster of the silver itself and from the rounded forms of the seed pots, express the genius of the American Indian craftsman-artist.

We at the Heard Museum express our deep appreciation to our friend Norman L. Sandfield for his generosity in gifting this collection, the finest of its kind, to the Heard Museum, and for his scholarship, enthusiasm, and support of this publication. The funding for this publication is made possible by Norman L. Sandfield, and the Dr. and Mrs. Dean Nichols Publication Fund.

This book is the result of the talents and hard work of many individuals. Its young author, Tricia Loscher, continues to make important and lasting contributions to the field of American Indian art history. Special thanks as well go to photographer Craig Smith, Larissa Orcutt, Kevin Coochwytewa, Lisa MacCollum, Nicole Haas, Angie Holmes, Shaliyah Ben, Sharon Moore, Diana F. Pardue, Ann Marshall, Mario Nick Klimiades, Betty Murphy, Carol Haralson, and Martha H. Struever.

All of us at the museum salute the creators of these magnificent silver seed pots. Small, lustrous objects, their stature far exceeds their size.

— **FRANK H. GOODYEAR, JR.**
Director, Heard Museum
February 12, 2007

NORBERT PESHLAKAI, Navajo, b. 1953
RECLINING IN THE SUN, c. 1994, Silver.

Foreword

"LOOK OUT THE WINDOW," Norbert Peshlakai said during my interview with him for a 1979 *Indian Artist* magazine article. "What do you see?"

I responded that I saw a telephone pole. "What do you see, Norbert?" I countered. Without hesitation he replied, "A cross."

It was a strong reminder that this artist's way of seeing the world was different from mine. As I would come to realize, Norbert Peshlakai has an exceptional talent for transposing everyday images into imaginary scenes. He does this on small silver "canvases" that are the pots, pins, and bracelets for which he has become so widely known over the past thirty years.

When I first became professionally involved with American Indian art in 1975, I gave considerable thought to my objectives as a dealer. I sought out beautiful yet unusual objects for my new Chicago gallery, which in terms of contemporary art meant identifying artists with truly innovative design capabilities. In jewelry, I wanted to introduce new ideas to collectors, many of whom were only familiar with traditionally recognized forms of American Indian art.

In 1978, during one of my frequent trips to the Southwest, I visited a prominent Santa Fe gallery known to carry interesting jewelry. My eye was drawn to a case holding a group of small silver pots; they were just the kind of attractive and unusual objects to carry in my Chicago gallery. I learned the pots were made by a young Navajo silversmith, Norbert Peshlakai. He was related by marriage to a sculptor, John Boomer, who had suggested to him the idea of making silver pots, and the young artist was excited to try a new form. The gallery graciously provided Norbert's address, and upon returning to Chicago I wrote him to ask if we could meet in Gallup, New Mexico, on my next trip so I might purchase some of his recent work. He agreed, and when we met he showed me several small silver pots, each in a cloth bag hand-stitched by Norbert and his sister. Thus began my long relationship with one of today's most creative silversmiths.

My approach to presentations in the Chicago gallery entailed mounting handsome single-artist exhibitions featuring pottery, jewelry, or textiles, with the artist in attendance, and in June 1979 I invited Norbert to participate in the opening of such an exhibition of his work. It was his first gallery show. The travel logistics must have been bewildering, as he had grown up in the remote Crystal area of the Navajo Reservation, but he seemed genuinely pleased to come so I mailed him a plane ticket. Upon his arrival, he told me that his mother, a weaver, had finished and sold a Crystal-style rug in part to provide him with travel money.

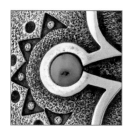

Norman L. Sandfield visited the gallery between Norbert's first Chicago show in June 1979 and his second show in February 1981. I was pleased when Norman visited my gallery, for he had genuine enthusiasm for art and we always had interesting discussions. Norman was a serious collector of *netsuke*, finely carved Japanese miniatures in ivory or wood, and was active in a group of *netsuke* collectors. He was a friendly, outgoing man with a keen eye for skilled craftsmanship, so I wanted him to see Peshlakai's silver pots. He liked what he saw and went home with two small silver containers. We stayed in contact and, as new pots arrived from Norbert, additional examples were added to the Sandfield collection. I began to see a few small silver pots by other artists, so I made certain that Norman became aware of them as well.

One day as we talked, I suggested to Norman that he attend Indian Market, the large Indian art fair held each August in Santa Fe, New Mexico. I told him that Peshlakai would be exhibiting new works there, and he could possibly find other artists as well creating pieces that might fit his collection. Norman has the quick, intuitive sense of a real collector, and he immediately agreed that he should attend Indian Market to see what was there. This visit in 1985 piqued his interest in acquiring works by a range of silversmiths. We continued to meet occasionally and to discuss his ongoing search for new artists. I understood the effort he was expending to build an exceptional collection, so I suggested he try commissioning works from artists who didn't usually make containers. I provided some names of artists to give him new contacts, knowing he would encourage each craftsman to do his own interpretation. Norman's only request was that no container should be more than 3 inches in diameter.

As I recall that modest beginning when Norman Sandfield bought two Norbert Peshlakai silver pots at my gallery, I am delighted to see that he has built a collection extraordinary in both quality and size. With determination and unfailing taste, Norman has assembled more than 240 unique containers by over seventy artists, which he is now presenting to the Heard Museum. His generous gift allows us all to appreciate the diversity and creativity of the many American Indian silversmiths working within a single new art form.

— **MARTHA H. STRUEVER**
Santa Fe, 2007

Collector's Preface

I HAVE BEEN ACTIVELY PURSUING and collecting silver seed pots since they first emerged as a contemporary Indian art form in the mid-1970s. I have always wished that I had the talent to create art—to make beautiful miniatures like these pots. While I will never fully understand the pleasures they give to the artists who create them, I do understand how to appreciate the talents of those who transform simple sheets of silver into beautiful miniature artworks that can turn any head and make many collectors envious.

Collecting for most is a passion, maybe even an addiction. As with any great passion, this one brings many rewards; not only aesthetic joy, but also the opportunity to travel, meet artists, and make new friends. My love of these fine miniature works of art led me to become a patron of the medium; to encourage the artists by purchasing their pieces, and to commission pots from talented jewelers/silversmiths who had never made silver seed pots.

A long history of beautiful ceramic vessels, made by American Indians, inspires the artists who make these silver seed pots. These exquisite miniature works of art incorporate design elements from traditional Navajo and Hopi pots, textiles, and baskets, as well as other sources. The artists who create them bring together the best of two worlds, taking designs that were previously in the domain of American Indian potters, weavers, and basket makers, and adding to them their modern talent for working with silver, gold, and stones. They bring their experience as designers and makers of fine jewelry to these jewelry-like miniature works of art. While not functional, the pots contain the spirit of traditional vessels made by the artists' ancestors. These vessels continue an ancient heritage of storage pots that were more than simply utilitarian objects—they incorporate elegant silhouettes, precise exterior designs, and the occasional surprise of interior decoration or embellishment.

This collection of more than 240 silver seed pots by more than seventy contemporary artists is now available to a wider audience because it has been donated to the Heard Museum, where the pots will be available for display and research in Phoenix, Scottsdale, and Surprise, Arizona. Much more than an assembly of individual pots, this body of work can now be seen and studied in its entirety as a coherent collection. The decision to donate was made with the knowledge that in their new home the pots will be seen and enjoyed by many more people than would otherwise be possible. It is very rare that a new art form is recognized from its very early days, purposefully collected, and documented from its inception; it is even more unusual that the resulting collection becomes available for public viewing so quickly. I am one of those lucky few to pass on my collection to a fine institution like the Heard Museum, and I deeply appreciate this honor.

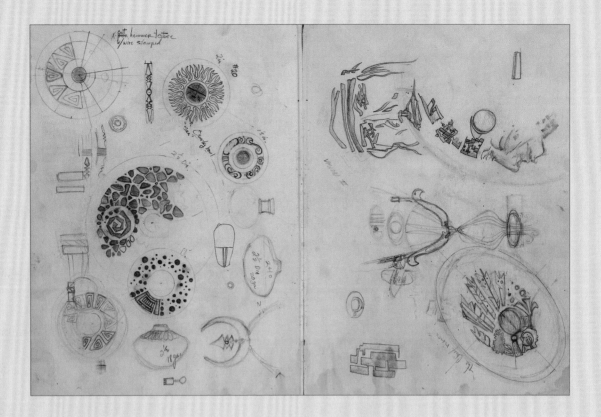

At its most basic level, collecting is about accumulating and possessing objects that we do not need for survival. But true collecting is about more than accumulating; what distinguishes the activity is the focus brought to the endeavor. I found that focus in these silver seed pots.

Other serious collectors of American Indian art were surprised when they saw my growing body of art in a form unfamiliar to them. "Where did they come from?" and "We've never seen anything like this before!" were common responses. I would tell them that this was because they were not in the Plaza in Santa Fe in the predawn hours before the opening of Indian Market as I was. Or at the front of the line to enter the Heard Museum Guild Indian Fair & Market in Phoenix, or the Eiteljorg Museum's market in Indianapolis. This is not a big secret, but it is a very effective method for acquiring the best in a collecting niche. In August 2006, I bought a silver pot at the Santa Fe Indian Market at 4:45 in the morning. I was there early to check each artist's location, and Rainey Julian was also there, to set up his booth before the crowds of artists and their vehicles arrived. The pot I had admired at the exhibition the night before was now mine. Half-an-hour later I bought another pot. Before 9:00 a.m., when most visitors and collectors were just getting warmed up, I had acquired eight beautiful silver seed pots!

(above) Pages from Norbert Peshlakai's sketchbook. Collection of the artist.

Collecting for most is a passion, maybe even an addiction.
As with any great passion, this one brings many rewards;
not only aesthetic joy, but also the opportunity to travel,
meet artists, and make new friends.

— NORMAN L. SANDFIELD (2006)

However, that was not the end of my search. That day I visited every booth and every artist to see who had made silver pots and who did not make pots but had the potential—the talent and technique—to make one for me. In spite of my persistence, I had not been as thorough as I thought. As I was finally leaving the market on Sunday afternoon, at the last booth, at the end of the last aisle, I spotted the large silver pots made by Gene Billie, which I had missed previously. A quick conversation with the artist, an exchange of business cards, and a small pot was commissioned. It showed up at my home less than two months later. How beautiful it is! Now you know at least some of my collecting secrets.

When asked why I collect these specific items, I have no perfect answer, but the contemporary seed pots relate to the Japanese *netsuke* that have been my other passion and my business for more than 30 years. *Netsuke* are finely carved miniature toggles worn by Japanese men in traditional dress to suspend objects from their sash belts. Recently, I discovered parallels in my collecting to that of two other passionate collectors. Adam Clark Vroman (1856-1916), known as "the photographer of the Southwest," and I have a several things in common, but in reverse! First, Vroman was born in Illinois; I now live in Illinois. More importantly, on Vroman's last tour of the Southwest in 1904, his collecting interests turned from rare books and Indian arts and crafts towards Japan and collecting *netsuke*. More than 100 years later, I started my serious collecting with *netsuke* and the related books before taking on American Indian arts and the silver seed pots. This is a coincidence, but one that I enjoy!

The other collector with whom I shared an interest in *netsuke* was His Imperial Highness Prince Norihito Takamado of Japan (1954-2002), first cousin to the Emperor. Princess Takamado referenced her late husband's *netsuke* collection when she stated, "My husband often used to say that the Japanese take things that are for everyday use and create such refined versions that they are elevated into the realm of artwork." This is as true of the silver seed pots as it is of the *netsuke*.

I would like to thank Martha Struever, who has been my dealer, mentor, friend, and supporter for more than twenty years. She initiated my transformation from an occasional buyer of small pots into a serious collector of them when she suggested that I attend Indian Market in Santa Fe years ago. Neither of us had any inkling of what would evolve from this! Marti supports not only collectors like me but the artists as well. It was she who taught me that I could commission artists to make a pot for my collection, and over the last several years I have done so with great enthusiasm and success. I thank her for her knowledge and friendship, for writing the foreword to this book, and much more.

I thank Joan Goldstein for being my friend, travel companion, and shopping enabler for more than thirty-three years. I introduced her to American Indian art and jewelry on a trip to Santa Fe for Indian Market one year, and from this initial encounter she went on to become involved with Crow Canyon Archaeological Center. Her collecting and love of ultra-miniature pottery seed pots by Indian artists has taken us to many Indian markets and events across the country, where there is always time for shopping. As an understanding collector, she shines in celebrating with me every purchase of a new pot or the discovery of a new artist.

To the artists whose work I have collected and whose talents I envy, I extend my hope that this book and the Heard's exhibit will meet your expectations. In so many ways this collection is about you, your cultures, your talents, and your heritage. I hope that the exhibition inspires future artists to create silver seed pots with their own stamp of individuality and creativity. May this collection also inspire future collectors to find some special collecting niche that they can love, collect, document, and eventually share with the world.

The opportunity to share what has given me such great pleasure with an immeasurably wider audience through publications and exhibitions at the Heard Museum is something I had never even dreamed of. I have no donor's regrets! I hope that future generations of readers, collectors, and artists will enjoy reading about the pots and their makers and seeing the superb photographs in this book. I hope that many will visit my pots at the Heard Museum to gain an insight into one corner of contemporary American Indian art. Seeing them as a group, up close, it will be clear why I found them so beautiful and collected them with such a passion!

— **NORMAN L. SANDFIELD**
Chicago, 2007

Introduction

CULTURES THROUGHOUT THE WORLD have held vessels in great esteem. Containers are known to hold visible items of value, but they also hold thoughts, prayers, and other forms of sustenance. On the spiritual level they relate to the human need to protect what is sacred, and as articles of everyday utility they play an intimate and very personal role in our lives.

In 2003, the Heard Museum North Scottsdale, Arizona, presented an exhibition devoted exclusively to a wide array of metal containers, including silver seed pots, tobacco canteens, purses, tea sets, and boxes. The talents of many artists from across the country were revealed in these historic and contemporary works of art. Most of the stunning 300 containers displayed had never before been exhibited. Many were part of the Heard Museum's permanent collections; some were made specifically for the exhibition; others were on loan from artists or private collectors throughout the United States. The vessels were created primarily in silver, occasionally adorned with turquoise, coral, wood, gold, or semi-precious stones. All revealed the vividness and uniqueness of genuine artistic expression.

It was during the process of curating the exhibition that I had the pleasure of meeting collector Norman L. Sandfield. I had asked to borrow twenty of his pots, but instead he sent sixty-five. Sandfield recounts the story: "I had no idea what the show was really going to be about but I knew my collection and the treasures it held. While they may have been shocked to hear that I was sending sixty-five pots, apparently there were no regrets when the packages were opened. With great excitement I flew to Phoenix for the opening in Scottsdale of the *Metalworks* show." Now, four years later, these pots and more are part of the Norman L. Sandfield Collection at the Heard Museum.

Each silver miniature of the more than 240 in the Sandfield collection is in some way an essay on the life of a particular artist—the pots reveal their makers' insights and interests, their environments and experiences, as well as their knowledge of the ancient art of metalsmithing. From fourth generation Navajo silversmith Norbert Peshlakai's stampwork alphabet to Blackfoot/Narragansett artist Tchin's *Medicine Wheel* pot, we see the lives and work of the creators reflected in the expressive iconography of the miniature forms. Upon close examination, it becomes apparent that each pot also reflects an artistic, social, historical, and geographical context. The majority have been made since the 1980s, but the collection also features several significant early pieces dating from the 1930s. From a 1955 pillbox to a glittering fourteen-karat gold pot with a butterfly design, they employ a diverse range of styles and techniques subtly evocative of their eras.

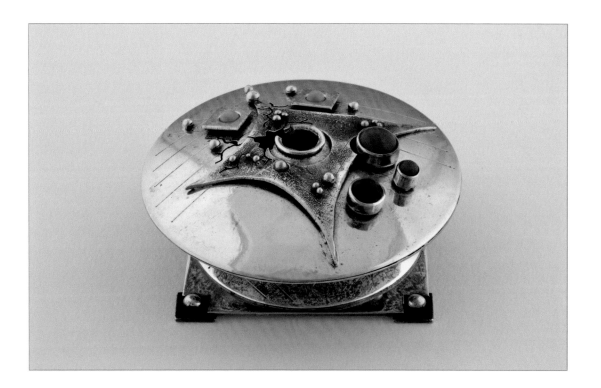

The pots in the Sandfield collection are inheritors of the ancestral traditions of both sacred and utilitarian vessels. In a sense, the historic seed pot was both—it was a useful object that held the gestational power of the next season's sustenance, and thus the life of the people. Corn, squash, and other seeds were stored in these clay pots with their characteristically small openings intended to keep their contents dry. At planting time the pots were shaken or broken to release the seeds.

Artist L. Eugene Nelson's silver seed pots acknowledge their origin in the more fragile medium of clay by incorporating a "firing crack." According to the artist:

My pots looked 'too perfect.' Something was missing. I then remembered a thing the potters had told me. Because of the unusually wet rainy season, they were losing some of their best pots. Clay pots need to be completely dry before they are fired. Due to the extra moisture in the air, the pots were cracking or breaking during firing. Remembering this, I realized that my miniatures needed their own individual 'crack' to be more sculptural, artistically pleasing to me. So before I solder together the two halves of the pot, I make a 'crack' in the opening. Some cracks will be more pronounced than others due to the design on the pot.

(above) L. EUGENE NELSON, Navajo, b. 1954, STAR WARS SERIES, 1995, Silver, fourteen-karat gold, coral, lapis lazuli, turquoise.

Highlights of the collection include Norbert Peshlakai's *The Cube*, a six-sided silver paperweight that resulted from a commission by Sandfield. Although the commission did not produce a traditional pot form, the collector was delighted with the direction the artist took with the work. "I loved it," Sandfield says, "and that was all that was important to me. But then I saw that each side used a completely different metalworking technique and was even more in love with it." Peshlakai recounts the making of his first sterling silver cube:

The sterling silver cube was made during my teaching at Western New Mexico University in Silver City in the late 1980s. I met Stan Nowak, a German from Connecticut who challenged me to make a 2-inch cube in silver. Since it was going to have six faces, I wanted the design to be different on each face. One face using overlay has a Mimbres bird design from the university student union wall, the second face is a sunburst with a set coral, the third face is a water wave design using eight different stamps, the fourth design is textured, appliquéd and stamped, and the final face design is from a twenty-two-gauge guitar string imprint design.

In recent years, the Heard Museum has looked to add more contemporary silverwork and jewelry to its collection. The Sandfield pots strengthen its contemporary art holdings and document a new generation of artists working in what is a relatively new American Indian art form. As this remarkable collection continues to expand with pieces acquired by Sandfield and we gather information from the artists about their methods of production, materials, and thought processes, the collection becomes a forum for an ongoing dialogue about art and its place in our lives. It is joyful, awe-inspiring, and humbling to experience the creative works in this collection. A heartfelt thanks to their creators for the delight and insight they provide us.

— **TRICIA LOSCHER**
Curator and Program Director, Heard Museum North Scottsdale
December 29, 2006

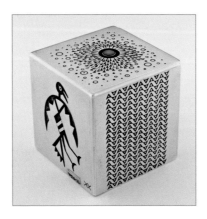 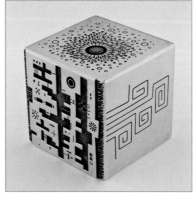

NORBERT PESHLAKAI, Navajo, b. 1953, THE CUBE, 1988, Silver, coral.

A Contemporary Tradition:
The Story of Silver Seed Pots

To me there is no past or future in art. If a work of art cannot live always in the present it must not be considered at all. The art of the Greeks, of the Egyptians, of the great painters who lived in other times, is not an art of the past, perhaps it is more alive today than it ever was.

— PABLO PICASSO (1923)

My interest and ideas in my work come from my love of Pueblo culture and history of New Mexico. [I am] further influenced by my love of the outdoors.

— **LORENZO TAFOYA (2006)**

EARLY ONE OCTOBER MORNING at the Heard Museum in Phoenix, Arizona, I met with artist Lorenzo Tafoya. Having six of his silver pots in the Sandfield collection, he carefully looked at each one and described it fully. As he reviewed his last piece in the collection, he related to me the process of how he made the designs on the seed pot from scrap silver and leftover cutouts. It was "a fun piece," he said, one in which he allowed the scrap pieces "to take a form of their own" on an unfinished pot originally intended to be a miniature goblet, creating abstract shapes that were "Picasso-style designs."

As I listened, I became increasingly more aware of how the pots in the Norman L. Sandfield Collection tell the story of every artist's search to know the world and him or herself. Like their ancient predecessors, contemporary seed pots employ a rich language of images and symbols. The manner in which the new lends to the old and the old enhances the new, however, is something everyone must experience for themselves, and a particular symbol or design may mean very different things to different artists. Sometimes the iconography of the silver seed pots is primarily personal. Though decorative, the symbols contain unrevealed meaning often known only to the artist.

The origins of the silver seed pot tradition can be traced through multiple strands of history. First, the pots are an extension of a centuries-old ceramic tradition. The clay pots from which the silver pots are derived originally served as utilitarian ware but were often embellished with their own iconography. We can also trace the antecedents of the silver seed pots to non-ceramic vessels. One of the earliest types of American Indian silver containers was the

tobacco canteen, which was copied from those made by the Hispanic people of New Mexico. Native canteens were made of silver, copper, and leather as early as 1880. In that year, Dr. Washington Mathews, an ethnographer for the Smithsonian Institution's Bureau of Ethnology, reported on Navajo silversmiths for the *Second Annual Report of the Bureau of Ethnology of the Secretary of the Smithsonian Institution, 1880-1881*. His article illustrates a canteen similar to those in the Heard Museum collection. Mathews noted that "tobacco cases, made in the shape of an army canteen, are made by only three or four men in the tribe, and the design is of very recent origin."

The silver seed pot tradition was also influenced by another phenomenon—tourism. During the late 1800s, railroads and other tourist-oriented companies promoted the Southwest as a land of exotic cultures and marvelous vistas. During the 1890s, interest in American Indians grew so rapidly that by the turn-of-the-century ceremonies, such as the Hopi Snake Dance had become major social events for outsiders. Throughout the years, a wide variety of American Indian items have been made for the tourist trade. Also known as souvenir or curio objects, these pieces have had a tremendous impact on indigenous art and ultimately the silver seed pot tradition. In a similar vein to the development of contemporary silver seed pots, the curio market overall has been driven by non-Indian traders and dealers, who by the early twentieth century were offering suggestions to American Indians for altering their work for predominantly non-Native consumers.

Navajo, MINIATURE CANTEEN, c. 1890, Silver, Gift of The Graham Foundation for Advanced Studies in the Fine Arts.

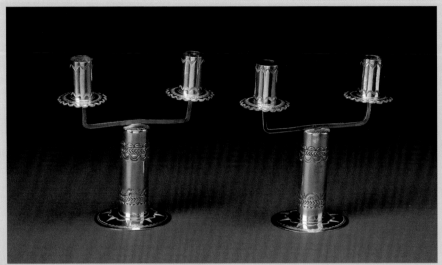

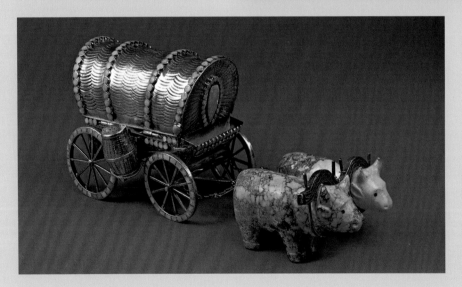

One alteration involved miniaturization, since smaller-scale items made of lightweight materials were more portable for tourists than larger, heavier, or more fragile ones. Another involved making objects familiar to non-Native users. Objects such as teapots and candleholders were now being made for a consumer market. The making of tableware dates back to early in the twentieth century, when the tourist market first began to be a factor in the production of silver. In the Heard Museum's collection is a very unusual silver and turquoise covered wagon pulled by turquoise oxen. On the side of the wagon are water barrels that serve as salt and pepper shakers. The wagon is an outstanding example of the exquisite workmanship that developed from the collaboration between artists. The wagon cover has turquoise drop inlay attributed to Zuni artist Frank Dishta, and Zuni artist Leekya Deyuse carved the turquoise oxen. By the time this piece was made, the combining of lapidary skills and silversmithing had become a firmly established practice among artists.

Morris Robinson's candlesticks are another example of fine silver craftsmanship and how it relates to consumerism. From the 1920s on, Robinson was employed by shops such as Vaughn's, Skiles Indian Store, and Fred Wilson's Trading Post in Phoenix to create unique pieces for customers. He is considered one of the first Hopi silversmiths to do so. Curator Diana F. Pardue has noted that Robinson's early work was similar to Navajo jewelry of the day, but as early as 1939, he was attempting to distinguish his work by the designs he used. Robinson made a variety of silver pieces, from candlesticks and bowls to many types of jewelry. Throughout his years as a silversmith, he won numerous awards at the Maricopa County Fair and the Arizona State Fair.

Ashtrays are another type of container that developed during the early twentieth century. They were sometimes made with silver conchos taken from belts, whose round or oval shape could be worked easily into a receptacle form. Some ashtrays incorporated large handmade beads as feet. Many collectors today consider ashtrays one of the most interesting types of silver containers because of the uniqueness and variety of their design.

(facing page, clockwise from top left) NORBERT PESHLAKAI, Navajo, b. 1953, POT, 1992, Silver, coral, turquoise, shell, jet, mother-of-pearl, sugilite. ■ MORRIS ROBINSON, Hopi, 1900-1987, CANDLESTICKS, late 1950s to early 1960s, Silver, Gift of James T. Bialac. ■ ROBERTA (BERT) JOJOLA, Laguna, MINIATURE JAR, 1990, Ceramic, Gift of Norman L. Sandfield. ■ ATTRIBUTED TO LEEKYA DEYUSE AND FRANK DISHTA, Zuni, 1889-1966 and Zuni, 1902-1954, WAGON AND OXEN, c. 1950, Silver, turquoise, Heard Museum Purchase. ■ (left) HOWARD SICE, Hopi/Laguna, b. 1948, POT, 1989, Silver.

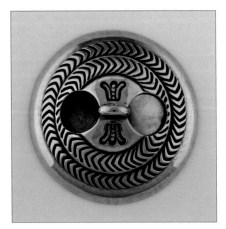 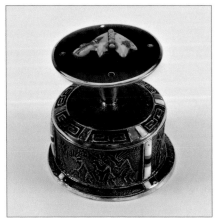 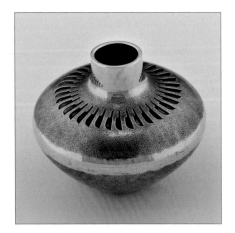

As with the use of conchos to make ashtrays, early silversmiths sometimes used coins to make beads. Today, the technique of doming two coins and joining them together to create a bead is recreated in the two circular flat silver disks that are domed and then joined together to make a miniature silver seed pot. One such pot created out of two flat silver disks by Norbert Peshlakai also has stone inlay. Describing the piece for the *Heard Museum Journal*, Peshlakai said:

This one I wanted to inlay with some stones and I went beyond the limit here. As I was inlaying the pieces I thought about God and said that it is really interesting the way he designed all these stones that came from the ocean. I was thinking about the ocean at the same time while I was grinding these stones. You have to use water [to grind the stones and] . . . I was thinking about the sea. I have a good time inlaying individual stones.

Miniatures of all kinds have been popular tourist-driven collectibles. As with the silver seed pots, they demonstrate on a small scale the fine workmanship and detail achievable by accomplished silversmiths and potters. Howard Sice creates micro-miniature and miniature silver seed pots. Of Laguna/Hopi heritage, Sice grew up carving katsina dolls with his father and brother, but he never thought of it as art. He made his first silver seed pot in 1985 and has made approximately 100 more since then, using sheet metal, metal fabrication, and hand-engraving. In Sice's words, "Since the beginning of humankind, we have sought to express the way we see the magic of our environment" and to "surprise the senses, challenge the normal, change the future" through art.

(above, left to right) KENNETH BEGAY, Navajo, 1913–1977, PILLBOX, c. 1955, Silver. ■ PRESTON MONONGYE, Mission/Mexican, 1927–1987, CONTAINER, 1973, Silver, turquoise, coral, shell, jet, ironwood, Heard Museum Collection. ■ NORBERT PESHLAKAI, Navajo, b. 1953, MARIA, c. 1995, Silver.

Silver has long been used to aid in health practices. Silversmiths have made containers to hold medicine and as amulets to protect their wearers. Silver also has anti-bacterial and non-contaminating properties that make it ideal for the storage of medicine. Pillboxes relate to both medicinal practices and the tourist trade. A silver pillbox made by Kenneth Begay circa 1955 was as novel for its time as the silver seed pots of the 1970s would be for theirs. Begay is considered one of the innovators in contemporary American Indian jewelry. According to Diana F. Pardue in *The Cutting Edge: Contemporary Southwestern Jewelry and Metalwork*, "Begay has influenced contemporary jewelers by directly teaching many of them and through the technical excellence of his work." He began by demonstrating jewelry making at Zion National Park and Bryce Canyon in Utah and at the Grand Canyon in Northern Arizona. He later worked for John Bonnell at the White Hogan in Scottsdale, Arizona, and it was at this time that his jewelry began to take on a contemporary appearance. Experimenting with ironwood and other materials, he created boxes, flatware, tea sets, candelabras, and silver chalices for religious purposes. As the chalice symbolically holds the body of Christ, the silver seed pots hold life-sustaining substances such as seeds for corn and other crops.

Mission/Mexican artist Preston Monongye is one of the innovators of expressive Southwestern contemporary jewelry. In *The Cutting Edge*, Pardue details how the artist's "technical and artistic achievements are evident in his tufa cast jewelry and non-traditional shapes and designs." She notes, "Monongye was aware of the evolution Southwestern jewelry was undergoing in his lifetime … an impeccable craftsman, Monongye could execute jewelry in the Hopi overlay technique, while his color choice in stones and personal style made his jewelry specifically his own." In 1970, he created a silver box that was awarded the grand prize at the Gallup Inter-Tribal Indian Ceremonial in New Mexico. The winning piece was the first all-cast silver container entered in the Gallup show. In the mid-1930s he learned to work silver from his uncle, Gene Pooyouma. Monongye served in World War II and in the Korean War before beginning his career as an artist full-time in the mid-1960s.

The recent history of silver seed pots dates to approximately 1975, only five years after Monongye's silver container was exhibited in Gallup. The silversmiths credited with making the first miniature silver pots are Norbert Peshlakai and White Buffalo, a.k.a. Mike Perez. The pots drew upon the classic forms and designs of ceramics, evolved through the art of silversmithing. As Norman L. Sandfield describes it, "These artists are jewelers first, and the pots are an extension of that field. As with any business-savvy artist or craftsman, they are always trying to expand their horizons and serve the needs of an ever more demanding collecting clientele and audience." Sandfield points to a Peshlakai pot inspired by the work of the famous San Ildefonso potter Maria Martinez as one that clearly demonstrates the convergence of jewelry and pottery in the miniature seed pot tradition. The pot was made at a time the artist "was fascinated by Pueblo pottery shapes and forms, particularly Maria's feather bowl or plate form," says Sandfield.

It is no accident that the Norman L. Sandfield Collection at the Heard Museum holds the largest single collection to date of Navajo artist Norbert Peshlakai's miniature silver seed pots. Sandfield calls Peshlakai "the dean of the silver pot." Peshlakai's booth at Indian Market is "always at the top of my list," he continues, "because I know he will have something new and creative to surprise me with." The name Peshlakai [written in Navajo as *Béésh łigai*] in fact means "silver," and the artist represents the fourth generation in his family to practice the silversmith's art. Peshlakai was born in 1953 in Crystal, New Mexico. His artistic talents are also evident in his jewelry making, sculpting, and painting. Peshlakai recounts how his inspiration for making silver pots arose:

After attending Haskell Indian Junior College in 1976, at the encouraging of John Boomer, a known wood sculptor and married to my cousin, I made my first silver pot. When I saw his woodcarving, it struck my attention and I showed a few of my jewelry pieces to John. I remember he asked me if I ever thought of making a silver pot. I did not hesitate and said 'yes.' It was not until a year later John came to my house at my Crystal Mountain shop to ask me to help him with building his double hogan log cabin. I packed my belongings and moved to his ranch. We started the foundation on the hogans . . . and John asked me if I had brought my silver, which I had left at my shop. I remembered I had some 3-inch by 6-inch eighteen-gauge silver sheets and we went to get it after work. He gave me a space to work in his shop and a block of walnut wood. I carved some hollow circles to shape my first silver pot, which took me almost one week to complete. That was my first 3-inch diameter sterling silver pot with a flare neck. After that, I wanted to do more silver pots so I arranged with John to buy me some silver out of my pay, which I used to make thirteen different kinds, shapes, sizes and freeform shapes, some had large necks and stone inlays. The year was 1977. After doing the pots, I switched back to jewelry and to my amazement, my designs for jewelry completely changed.

During an interview at the Heard Museum in March of 2006, Peshlakai spoke of his relationship with Sandfield: "When I met this fellow he started collecting the pieces. From there it made me motivated to keep working on the silver project … I started texturing the pieces and started designing and experimenting around with a lot of different textures and stampwork, and adding tools to it." It was Martha Hopkins Struever who introduced Sandfield to Peshlakai's work, and as she aptly pointed out in her 1997 article for *Indian Artist*, "Throughout his artistic career, Peshlakai has been a wellspring of ingenuity. In the manner of the early Navajo silversmith, he has taken the most basic of tools and customized them into unique and highly specialized implements."

Some of the stamped designs on Peshlakai's silver pieces were influenced by textiles woven by his mother. He also derives inspiration from images he sees in the world around him. Commenting on one of his silver pots with an owl design, Peshlakai revealed, "The way I look at my artwork is I think about the Creator God, who created all of these things. It's not like a

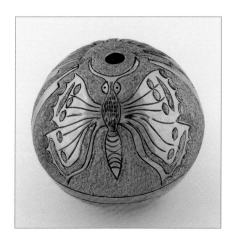

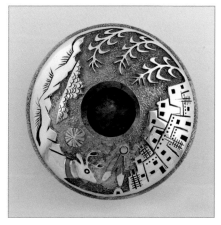

(top) WHITE BUFFALO, Comanche/ Mexican, b. 1946, POT, 1978, fourteen- karat gold. ■ (bottom) LORENZO TAFOYA, Santo Domingo, b. 1951, DISCOVERY OF PARADISE, 2000, Silver, fourteen-karat gold, turquoise.

ceremonial thing. It's beautiful. I love animals." This love for animals and nature is evident in the stamps and designs on his pots. Speaking of his Mimbres rabbit design, he says:

Steve Northup took some pictures of my artwork for [the book] Southwestern Indian Jewelry *by Dexter Cirillo. Steve came to my home in Fort Wingate at that time in the early 1990s. We talked while he took some photographs of some of my hand-hammer texture, stamped, and appliquéd silver pots. Steve told me about his home in the outskirts of Santa Fe where there are wild rabbits that run and jump around his home every now and then. Sometime after, he sent me a letter with a postcard of a drawing of a Mimbres rabbit design. I decided to use the design to create my large Mimbres rabbit belt buckle. It took about ten individual stamps to complete the rabbit. That was the beginning of the many animal designs on my work.*

Peshlakai makes his own stamps and to date has made approximately 260 of them. Peshlakai's daughter Natasha and son Aaron are also silversmiths, each making silver seed pots. Peshlakai's technical expertise has influenced not only his family but numerous other silversmiths, such as Darryl Begay, Anthony Lovato, Darrell Jumbo, Myron Panteah, Duane Maktima, and Kenneth Peshlakai.

White Buffalo, a.k.a. Mike Perez, was another of the first artists to work in the tradition of miniature silver seed pots. In 1975, the *Albuquerque Journal* published an interview with White Buffalo along with photographs of the artist working on his small silver pots. White Buffalo said, "I like to work with my hands and began some five years ago [1970] creating with paint and sculpture. During this time I was a design engineer for the Fairchild Company, but I always wanted to be an artist. The first thing I made was a silver and turquoise bracelet for my little boy." White Buffalo progressed from working in silver to gold. A photograph in the June 7, 1978 *Gallup New Mexico Independent* newspaper shows Perez and his daughter, Maria, each holding a small gold vase in their hands.

The steadfastness and dedication that artists such as Peshlakai and Perez maintain throughout their creative journeys is reflected in their meticulous work. During the creative process, artistic thoughts can become realities, and as the thoughts translate themselves into material things they are reflected in the themes and designs of the silver seed pots. The human figure is one notable motif for potters and silversmiths alike, and artists have explored a range of human forms drawn from various time periods to adorn

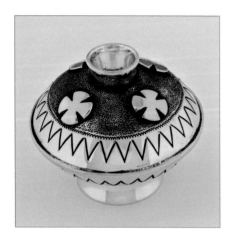 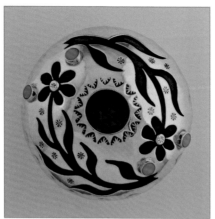 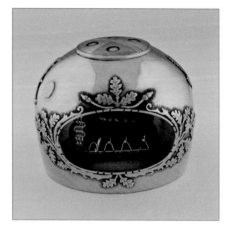

their seed pots. In his work titled *Discovery of Paradise*, Lorenzo Tafoya depicts the journey of Spanish conquistadors and their discovery of Pueblo culture, which Tafoya represents with a multi-story pueblo, corn plants, clouds, mountains, mesas, and feathers. A mule deer with a turquoise collar denotes respect and honor. There is also a sun symbol made of gold.

Across the continents and throughout the ages, precious vessels of gold and silver have played an important role in rites and ceremonies. The oldest piece in the Sandfield collection, a miniature Incan metal cup from Peru dating to about 1000 C.E., underscores this long history, although it does not directly relate to the newly emerged modern tradition of miniature silver seed pots. The attractiveness, patina, and intrinsic value of silver have made it an object of veneration and desire for centuries. Sacred numbers are often associated with the seed pots, as seen in Victoria Adams' pot with four Morning Stars. The stars represent the four directions and the four major phases of life: childhood, youth, maturity, and elder years. Lorenzo Tafoya's silver seed pot with flower designs depicts the four directions and four seasons, which are demarcated by four Sleeping Beauty turquoise stones.

The contemplation of design motifs can draw viewers into a deeper understanding of American Indian art and culture and a greater awareness of cultures other than one's own. For example, a seed pot adorned with abstract designs of life-sustaining corn may direct the viewer's mind toward the importance of this food for indigenous people. In the Sandfield collection, a unique silver pot that opens on its side, by Starlie Polacca III, contains a story of the importance of corn. Every detail is accounted for, down to the artist's choice of the silver's finish. Polacca comments:

(above, left to right) VICTORIA ADAMS, Southern Cheyenne/Arapaho, b. 1950, POT, 2002, Silver, eighteen-karat gold. ■ LORENZO TAFOYA, Santo Domingo, b. 1951, POT, 1999, Silver, fourteen-karat gold, Sleeping Beauty turquoise. ■ STARLIE POLACCA III, Havasupai/Hopi-Tewa, b. 1948, HAVASUPAI SEED CORN, 2006, Silver, copper, fourteen-karat gold, rose quartz, mother-of-pearl.

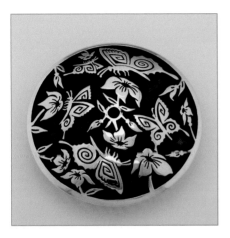

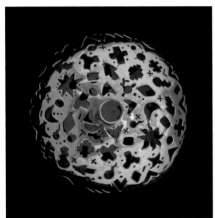

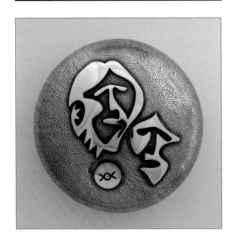

The design on top is from the Havasupai Tribe. The bighorn sheep represents the Havasupai People. The birds are the spirits of the ancestors. The right hand—the good direction the child should follow. The baby is in a traditional Havasupai cradleboard. The seed corn is seed you'll be planting next spring. You want to protect it as best you can, otherwise you may be doomed . . . The hole in the side is to allow the viewer to see inside the pot. I thought of making it in the style of Fabergé's eggs. Open it and be surprised but too much touching causes silver to tarnish. I chose a matte finish. A bright mirror finish, I felt, would give the piece a sterile and unfeeling look.

Polacca began making miniature silver seed pots in 1980 and to date has made twelve. He was influenced by the pottery miniatures of artists such as Tony Da, Joseph Lonewolf, and Art Cody. The old masters from Fabergé's workshops, Lalique and silversmith Robert Koeppler, also influenced the artist. Polacca's mother, now eighty-two, makes pottery and cradleboards.

The pots of Gene Billie also convey cultural themes through their sculptural shapes and designs. Billie says, "The designs on pottery, whether it is ancient, traditional, or contemporary, they all tell a story. I use the same concept to make the piece meaningful . . . I like the idea of making pots based on ones made many years ago by our ancestors for their survival and everyday living. I like creating miniature pots resembling the shapes of ancient pots and adding a creative twist to give my sculptural pots Native meaning."

Pots such as Polacca's and Billie's become more than representations of utilitarian seed pots. They transform to become sacred silver containers, symbolic of the manifestation of life power and the artist's desire to accomplish a great goal.

Nature and the cosmos have long been a great source of inspiration and meaning for artistic creations. The sun, stars, animals, plants, and insects are often depicted in the silver pots. As if created by nature, Jason Takala, Sr.'s seed pot is a balanced whole, with strong designs that depict butterflies and flowers "drawn right on the silver and cut out with a jeweler's saw, soldered and formed to its dimension." Takala made his first silver seed pot in August 1991 and has since made twelve more. Kee Yazzie uses designs that are "all related to stars and the sun." Forming his piece was a challenge, he says, as the silver pot is all one piece, top and bottom.

(top to bottom) JASON TAKALA, SR., Hopi, b. 1955, POT, 1993, Silver. ■ KEE YAZZIE, Navajo, b. 1969, POT, 1999, Silver. ■ NORBERT PESHLAKAI, Navajo, b. 1953, THE TWO FACES, mid-1980s, Silver.

Norbert Peshlakai's pot *The Two Faces* from the mid-1980s, part of the artist's Chief Series, was created with the Hopi overlay technique utilizing a two-face jigsaw puzzle design. The 3-inch silver pot consists of two circular cutouts of one-sided commercial textured sterling with appliqué and hand-hammering. The top of the pot is appliquéd and the reverse side is stamped and has cutouts.

Silver seed pots sometimes document other art practices such as textile weaving, as seen in Linda Lou Metoxen's first seed pot. Metoxen, whose mother is a weaver, says, "The figures on my silverwork are influenced by the Yei figures of the Navajo weavings. They represent the Holy People." The artist continues:

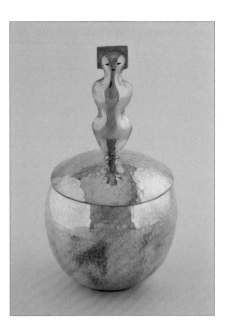

LINDA LOU METOXEN, Navajo, b. 1964, POT, 2006, Silver.

I didn't know anything about seed pots until Norman commissioned one. Norman has been asking for a couple of years. He explained what they were. I decided to make one. It was very challenging. I had a difficult time with it because seed pots don't have feet or a base and most of my pots are known for their flared-out base or figures holding up the pots. For me the pot seemed incomplete (more like naked), but with the figure on top it seems to work. I plan to continue making miniatures.

As evidenced in this collection, the pots can tell you a lot about their purpose and history. Many of the objects in the Sandfield collection are adorned with references to family, culture, and subsistence; symbols afford connecting links of thought from details to general principles. Decoration, or lack of it, can also tell you something about the person who made the pot. As seen in the pages that follow, the relatively recent manifestation of the silver seed pot tradition promises exciting adaptations, modifications, and harmonious collaborations, as each piece that is created continues flowing from the past through the present and into the future. How the personal expressions of the pots' creators will be modified and transmuted in the future is exciting and remains to be revealed.

NOTE: Unless otherwise noted, all of the pots in the Sandfield collection have a diameter not greater than 3 inches.

NORBERT PESHLAKAI

Navajo, b. 1953

PEOPLE

THE CHIEF VISION (PLAINS NATIVE TRIBE), 1990
Silver, coral

The Chief Vision has a crosscut-tip hammered texture, with an appliquéd chief's portrait on its stamped and hand-hammered oval body. The oval opening is off-center. The pot is a duplicate of an award-winning piece at Santa Fe's Indian Market that Sandfield commissioned from Peshlakai. It is one of Peshlakai's larger pots, with a width of 4¼ inches.

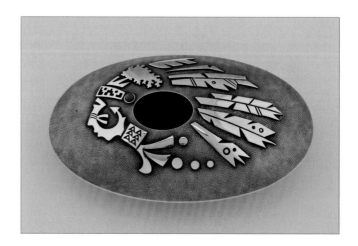

THE TWO FACES, mid-1980s
Silver

This pot from Peshlakai's Chief Series was created using an overlay technique and incorporates a two-face jigsaw puzzle design. The piece is made with two circular cutouts of one-sided commercial textured sterling. The top of the pot is appliquéd and the reverse side is stamped and cut out. This is one of Peshlakai's rare pots to employ commercially textured silver; the great majority are textured by the artist using a crosscut-tip or punch-tip hammer.

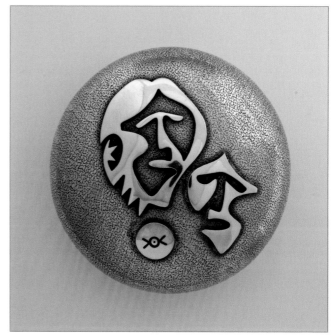

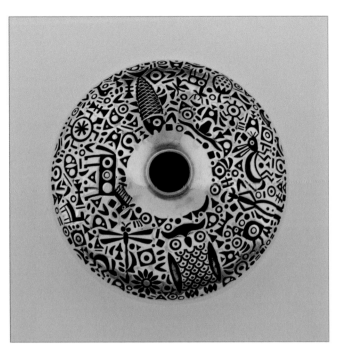

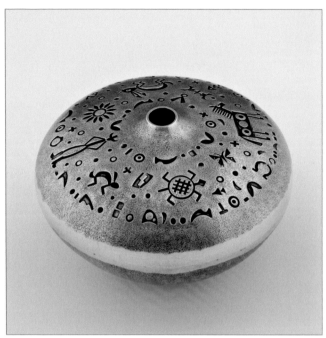

SLIM COWBOY WITH NATURE,
2005
Silver

This pot is stamped with many designs, including owls, fish, rabbits, dragonflies, flowers, and deer. It was purchased from the artist by Sandfield at the Heard Museum Guild's Indian Fair and Market.

SLIM COWBOY'S NATURE WALK,
1995
Silver, coral

Creating this pot entailed the use of many stamps depicting rabbits, horses, butterflies, sunflowers, geometric designs, and the sun. A small pot is stamped next to the stamped design of a cowboy. On the bottom, a stamped turtle design has been inlaid with a piece of coral.

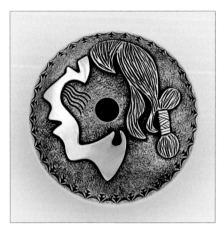
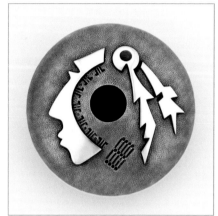
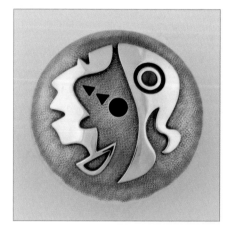

DINÉ, 2002
Silver

The profile of an American Indian that decorates this pot was made with appliqué and stampwork. The hair was stamped atop the appliqué and arrowhead designs were added.

INDIAN WITH TWO FEATHERS, 1999
Silver, coral

This pot has an American Indian face created with an overlay technique. The choker was created with stampwork, and two feathers were placed in the figure's hair. Beadwork is represented by the use of a single piece of coral. The background of the pot consists of a crosscut-tip hammered texture.

VOICE AND VISION, 1998
Silver, coral

The second or third piece in Peshlakai's Voice and Vision series, this vessel features a face in profile created with appliqué and stampwork. Cutout designs on the face represent vision. The pot has a crosscut-tip hammered background texture.

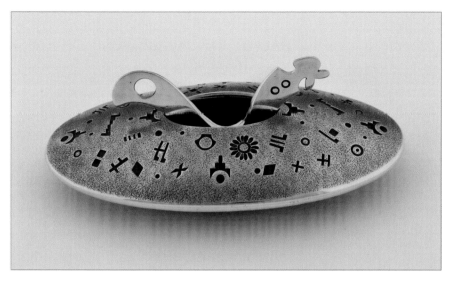

RECLINING IN THE SUN, c. 1994
Silver

Reclining in the Sun depicts a Navajo woman bathing. According to Peshlakai, "An amazing thing happened to me when I came back from Haskell Indian Jr. College. I was inspired by a famous sculptor, John Boomer. His art in wood sculpture attracted me—the curve, angle, circle, oval, and texture in some areas, but not too busy-body." Boomer's influence is evident in this pot.

THE THREE FACES, 1998
Silver

Three appliquéd faces show in profile on a pot whose background bears a cross-filed, hammered texture.

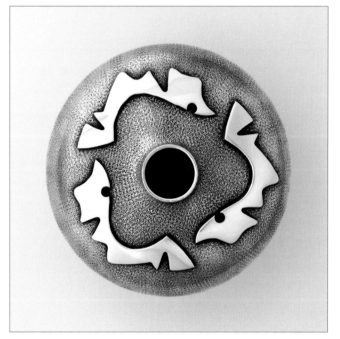

ANIMALS

FEATHER AND BEAR, 1984
Silver

Eighteen bears are appliquéd beneath appliquéd feather designs that emerge from the mouth of the pot.

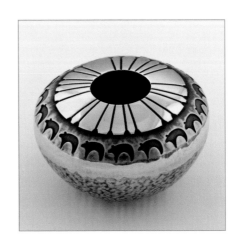

(facing page, clockwise from top left)

THE BEAR SEASON AND TURTLES, 2006
Silver, Sleeping Beauty turquoise, coral, white shell

This silver pot has a bear-shaped stopper, with a piece of white shell inlaid on the underside. Larger turtles are stamped on top of the pot and smaller turtles are stamped on the bottom. Geometric circles and lines are stamped throughout the top of the pot, and the background has a punch-tip hammered texture.

BEAR POT, 1993
Silver

Stamped bears and a hammered texture give this pot its visual character.

BLACK BEAR FETISH, 1998
Silver, ebony, mammoth ivory

This bear-stamped and hand-hammered pot with lid is a rather uncommon piece for Peshlakai since he creates few pots with stoppers.

RUNNING BEAR, 1989
Silver

Six appliquéd bears have been stamped with guitar-wire heartlines. The pot has a crosscut-tip hammered texture.

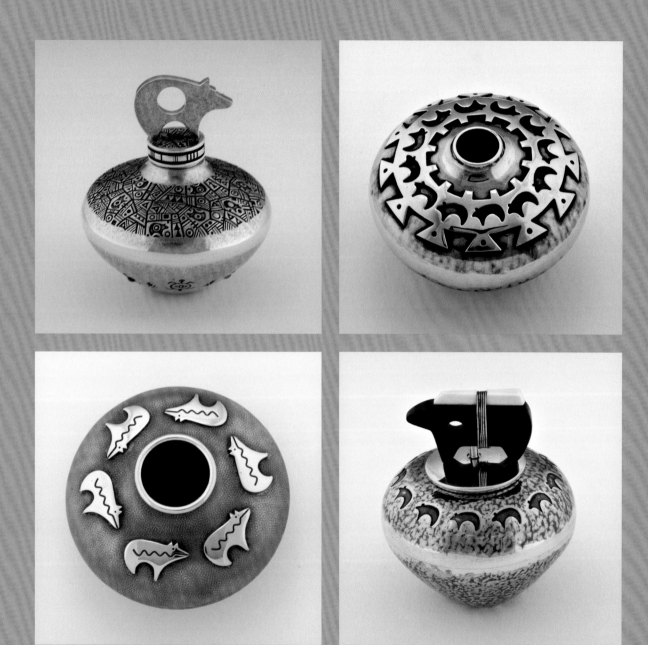

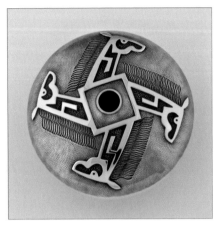 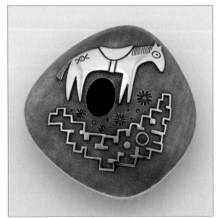 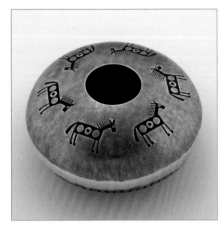

THE HORSE IN THE WIND, 2002
Silver

This relatively recent work bears four appliquéd horse heads around its mouth and is surfaced with a crosscut-tip hammered texture. Peshlakai made the head of the horse first and then stamped its mane with a curved stamp to create a wavy design.

HORSE I, 1999
Silver, coral

Peshlakai's free-form pots *Horse I* and *Horse II*, were made as a pair from the same silver cutout. One pot uses positive appliqué, the other negative appliqué. *Horse II* sold to another collector. *Horse I* has a crosscut-tip hammered texture and appliqué on a stamped, hand-hammered free-form shape. "Free-form shapes are a little bit tricky," Peshlakai says, "as the top and bottom have to be the exact size of sterling sheet silver."

HORSES, c. 1993
Silver

Two 3-inch cut silver circles form the top and bottom of this piece. The silver is stamped and textured, and the six horses' bodies encompass seven different stamps each for body, head, tail, leg, ear, mane, eye, and center punch on the body. There are stylized horseshoes on the bottom of the pot.

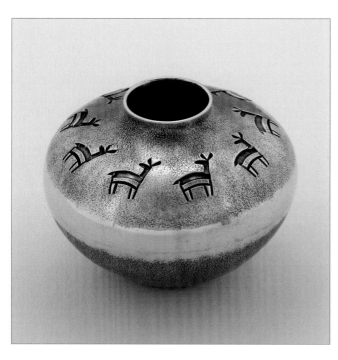

THE DOES, c. 1997
Silver

The design is of female deer. Peshlakai
worked with stamps of male deer for a
number of years, then added female deer
stamps to his repertoire.

THE BUCKS AND FOOTPRINTS,
1996
Silver

Peshlakai used a punch-tip hammered
texture, embossing, and stamped deer
on this plate. Each buck is composed of
seven separate stamps.

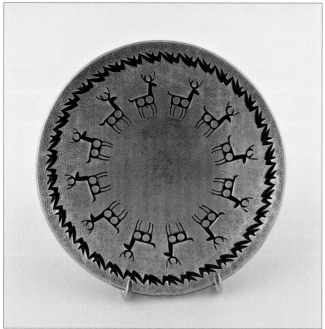

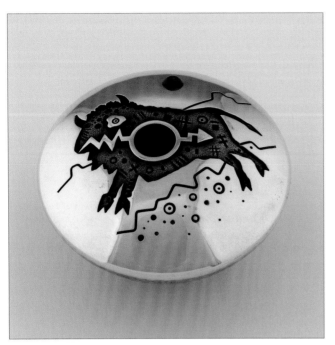

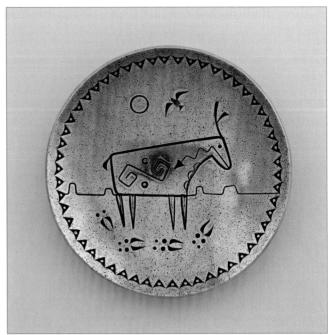

THE BUFFALO, 1994
Silver, coral

The Buffalo combines texture, overlay, and stampwork with hammering and red coral inlays. "This pot is a good example of negative and positive aspects in designs," says Peshlakai.

THE ANTLER, 1985
Silver

Peshlakai describes the process: "The plate is made from a 2-inch circle of twelve-gauge sterling, and the accompanying stand is made from ten-gauge round wire. The design was created using a steel string guitar wire to stamp the piece." This piece with its deer design was made only a year after Peshlakai first began making plates in 1984.

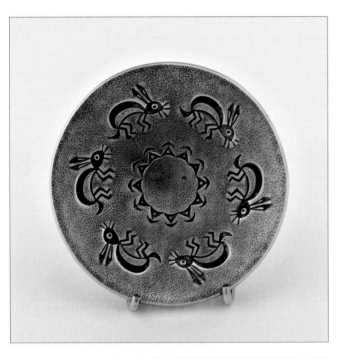

MIMBRES RABBIT, c. 1998
Silver

This plate was made from 2-inch cut circles. It has six rabbits stamped in a circle with punch-tip hammered texturing and embossing. Peshlakai made the stand to hold *Mimbres Rabbit* from silver round wire. The artist recalls that he decided to make some bowls and plates that exposed the delicate hammered texture of their interiors, and this piece was a result.

THE FOUR MIMBRES RABBITS, c. 1997
Silver

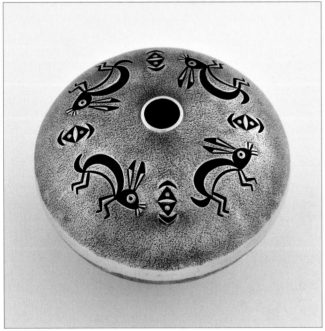

Four rabbits in the Mimbres-style are stamped on this pot, whose texture was achieved with punch-tip hammering.

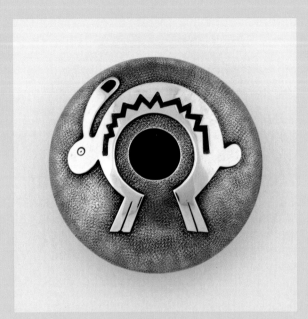

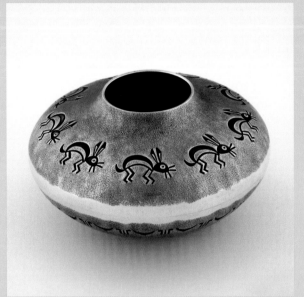

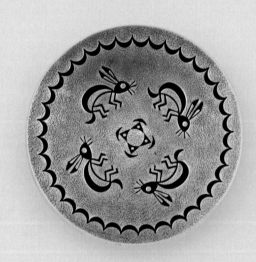

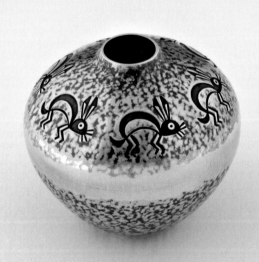

(clockwise from top left)

POT, 1993
Silver

An overlay technique was used to create a rabbit around the vessel's mouth.

POT, 1993
Silver

Six stamped Mimbres-style rabbits form the decoration for the pot.

MIMBRES RABBIT, C. 1993
Silver

This pot has nine rabbits stamped on the top and a geometric design stamped around the bottom. It is textured and hand-hammered with a flared opening. According to the artist, the body of the large rabbit required nine different stamps.

FOUR MIMBRES RABBITS, 1992
Silver

Four stamped rabbits and a cross-hammered texture give this plate its visual character.

THE QUAIL, 2004
Silver, coral, garnet

This pot was made with crosscut-tip hammer texture, appliqué, and stampwork. Peshlakai notes, "The Mimbres quail design was first made in a brooch or pin from my sketchbook. Later I used the design for this quail pot."

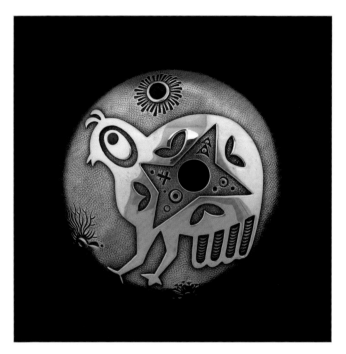

NIGHT OWL, 1990
Silver

Night Owl was made using six separate stamps for the head, beak, eyes, wings, and claws of the owl. The cutout oval shape forms the owl's body.

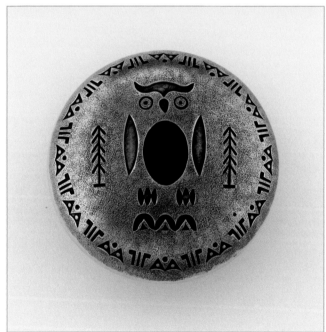

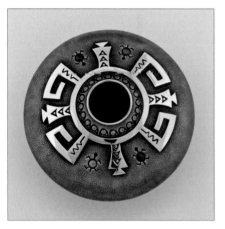 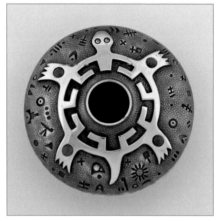 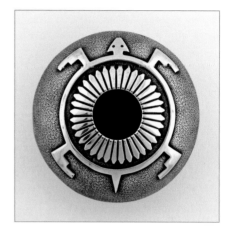

FOUR TURTLES, 1995
Silver, Sleeping Beauty turquoise, coral

Four turtles are appliquéd on the top of this pot with coral and turquoise inlay. The pot has stampwork and a crosscut-tip hammered background texture.

MOTHER TURTLE AND BABY TURTLES, c. 1993
Silver, Sleeping Beauty turquoise, coral

Turtles are one of Peshlakai's favorite design motifs. A large appliquéd turtle surrounds the mouth of this pot. There is also stampwork around the large turtle as well as three turtles on the bottom.

TURTLE WITH FEATHER, c. 1990s
Silver

A large appliquéd turtle surrounds the mouth of the pot, from which appliquéd feather designs radiate. The pot has a crosscut-tip hammered texture background.

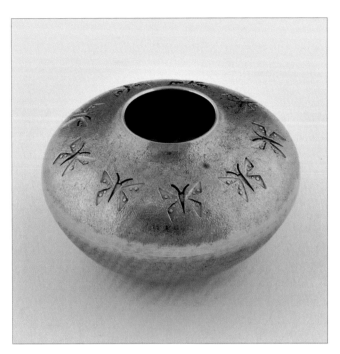 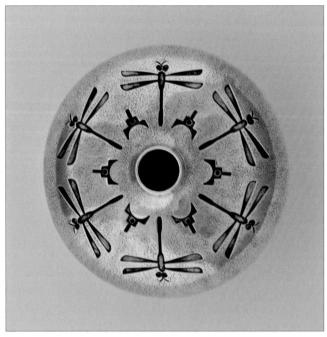

BUTTERFLIES AND DRAGONFLIES

THE BUTTERFLIES, C. 2002
Eighteen-karat gold

This is the second of two gold pots made by Peshlakai. The butterfly form is composed of three different stamps.

THE DRAGONFLIES, 1996
Silver

According to Peshlakai, "One day I wanted to do a new animal stamp. Dragonflies came to mind. I did some in my sketchpad. I couldn't come up with one, so I decided to look it up in the encyclopedia book. Sure enough, there was an illustration of a dragonfly and I created my dragonfly stamps from the book." The dragonfly is composed of six different stamps for the body, wings, eyes, and antennae.

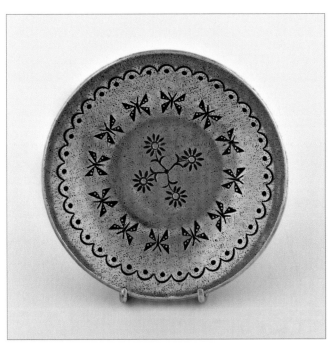

THE BUTTERFLIES, c. 1986
Silver

Peshlakai created this plate from a 1½ -inch circle cut from silver. It is accompanied by a handmade silver wire stand. The plate was stamped and embossed, its butterfly decoration composed of three separate stamps, one each for body, wings, and antennae. According to the artist, "Some of my miniatures were two or three pieces in a set. For example, either a pot and plate; or three pots in different form; or a pot, a bowl, and a plate. I notice some matched set pieces have been sold or traded, which broke up the set. Maybe this piece is one of them."

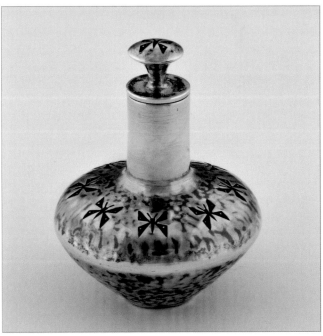

VASE, 1987
Silver

A hand-hammered vase with a flared neck bears a design of eight stamped butterflies plus a single butterfly stamped atop its stopper.

GEOMETRIC DESIGNS

(clockwise from top left)

MARIA, c. 1995
Silver

This pot was inspired by a feather bowl made by the famed San Ildefonso potter Maria Martinez. It is stamped, textured, and hand-hammered. Peshlakai honors the vessel's inspiration in both its design and in its title, *Maria*.

FEATHER FAN, 1994
Silver, coral

The designs consist of two appliquéd feather fans set with coral. There are arrowhead designs stamped around the feathers. The background has a crosscut-tip hammered texture.

ABSTRACT FEATHER DESIGN, 1990
Silver

The feathers are appliquéd and the vessel bears stamped designs. Its background has a hand-hammered texture.

FOUR FEATHER FANS, c. 1994
Silver

The design on *Four Feather Fans* is made up of four separate fan-shaped feather designs in four directions with four domes of silver. It was textured with a crosscut-tip hammer and appliquéd.

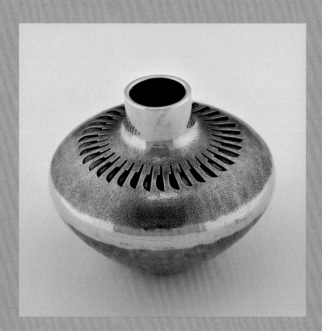 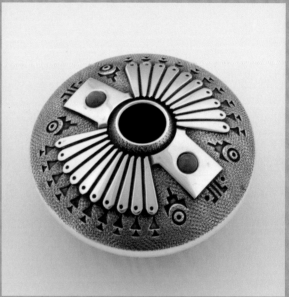

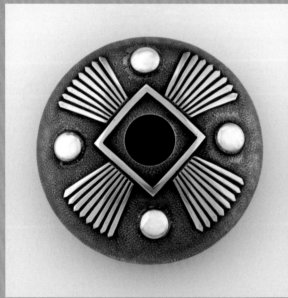 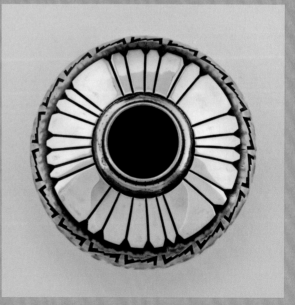

POT, 1992
Silver, coral, turquoise, shell, jet, sugilite

The multi-colored stone inlays on this vessel complement its overlay technique and feather designs. The pot won a first place ribbon at the 1992 Indian Market in Santa Fe.

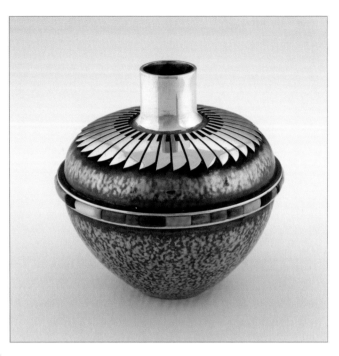

FEATHER VASE, 1988
Silver

This early vase is somewhat unusual for Peshlakai because of its long, flared neck. It has a hammered texture background.

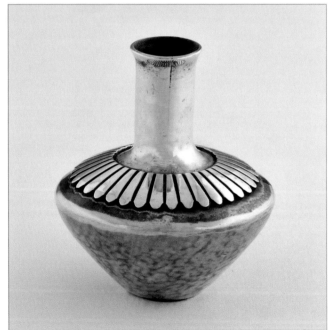

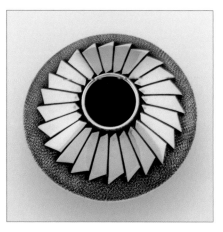 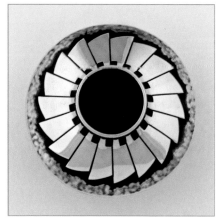 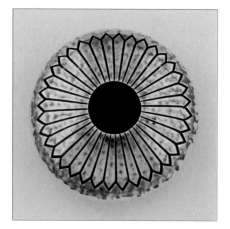

FEATHER POT, 1986
Silver

When Peshlakai was teaching at
Western University in New Mexico, he
exhibited his metalwork, and Sandfield
purchased this pot at that time. It
has appliquéd feather designs and a
crosscut-tip hammered background.

FEATHER POT, 1983
Silver

The eighteen feather designs
around the opening of this pot are
appliquéd on a background that has
a hammered texture.

POT, 1981
Silver

This pot has feather designs with
special V-shaped tips. The pot is scribed
and stamped and has a hammered
texture. This was one of the first two
Peshlakai pots Sandfield bought from
Martha Struever.

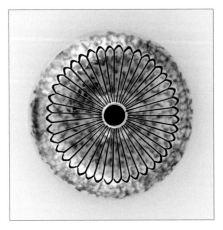 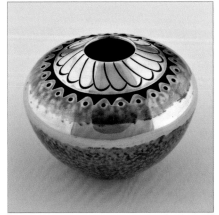 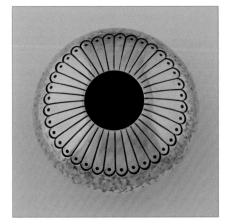

THE FEATHER POT, 1980s
Silver

This early miniature by Peshlakai, with its feather design around the rim, is one of the first two silver pots Sandfield bought from Martha Struever. Peshlakai says that when he made it, he had wanted "to try some very small pots, bowls, etc., 1-inch diameter and under. The smallest pot I accomplished was the size of my index fingertip."

FEATHER POT, 1978
Silver

This silver pot has feather designs created with the overlay technique. There is also stampwork on a hand-hammered background. The bottom is stamped with the copyright mark Peshlakai used in 1977 and 1978.

FEATHER POT, 1978
Silver

The feather designs around the mouth of this bowl are stamped and chased. There is also a stamped circle in each feather. The background texture of the pot has been finely hammered.

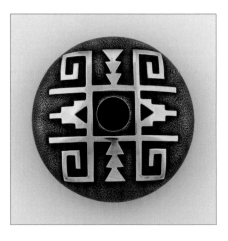 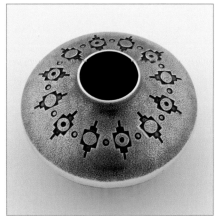 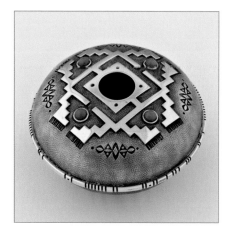

THE NAVAJO RUG DESIGN, c. 1978
Silver

This pot was made with cut sterling silver, 2 inches in diameter, with one piece for the top and a separate piece for the bottom. A third piece of silver was used to make the design. Both disks used to make the pot are hammered to yield a crosscut texture. The design pattern on the top of the piece is appliquéd. After soldering, the pot was oxidized, filed, steel-wooled, sanded, and machine-polished. As seen in this piece, some of Peshlakai's pots and plates are based on geometric rug pattern designs similar to those created by Navajo weavers from Two Grey Hills, New Mexico, and Teec Nos Pos, Arizona. It initially appealed to Sandfield because of its all-silver construction.

CRYSTAL RUG PATTERN, 1995
Silver

The top and bottom of the piece are stamped with design elements seen in Crystal rugs. The background has a punch-tip hammered texture.

POT, mid-1980s
Silver, coral

The inspiration for this pot was a Navajo rug pattern familiar to the artist from the work of his mother, a well-known weaver from Crystal, New Mexico. "She does a design of wings or step patterns in her weavings," says Peshlakai. "Crystals [as textiles from the area are called] are known for their water-wave pattern along with designs in between the waves." The pot was completed with crosscut-tip hammer texture, appliqué, and stampwork.

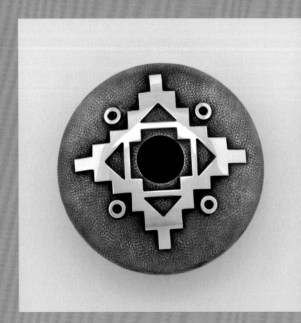
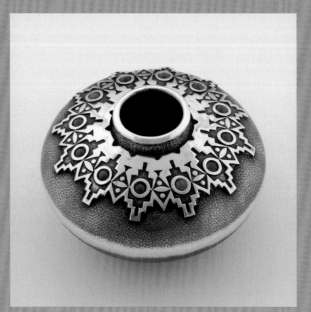
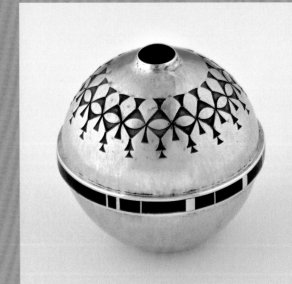
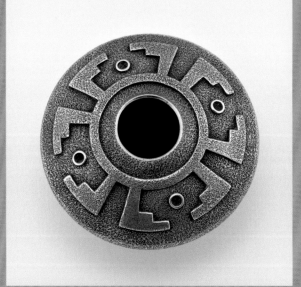

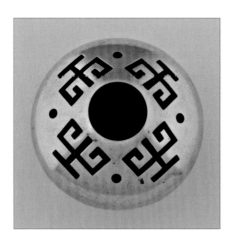

RUG DESIGN, 1980
Silver

The stamped motifs seen here are based on textiles. In order to create the texture on the pot, Peshlakai used a needle file and made rotations with it directly on the silver. He then polished the surface.

(facing page, clockwise from top left)

TWO GREY HILLS, 1992
Silver

The stepped designs seen here are based on textile patterns from Two Grey Hills or Teec Nos Pos. The background is crosscut-tip hammered.

MANY STARS, 1992
Silver, coral

Many Stars reminds Peshlakai of how "my grandma used a step block design in her weaving and called it a star pattern." The pot, which won a third place ribbon at the 1992 Indian Market in Santa Fe, is one of Sandfield's favorites.

THE FOUR DOUBLE WINGS, 1991
Silver

This pot has a four-wing pattern design that Peshlakai compares to the designs he has seen in his mother's weavings. The wings are of appliqué work, and the pot bears a crosscut-tip hammered background.

PENDLETON, 1978
Silver, ebony

Pendleton has stampwork consisting of arrowheads and geometrics, ebony channelwork, and a punch-tip hammered texture.

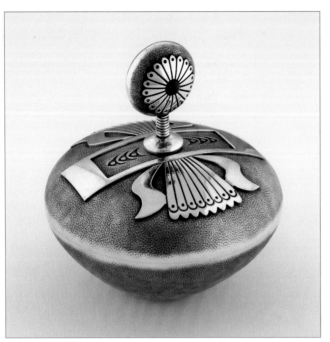

TRADITION, 2006
Silver, Sleeping Beauty turquoise, coral

This pot's design is fashioned after tufa cast belt buckles. It has an appliquéd feather design on the stopper and stamped designs of arrowheads on its body.

POT, 1985
Silver

The design on this pot reminds Peshlakai of "tufa designs I have seen on belt buckles." The two feather fans are appliquéd, and the arrowheads are stamped. A crosscut-tip hammered texture was used throughout. An early work for Peshlakai, this pot won a second place ribbon at the 1985 Indian Market in Santa Fe.

DIRECTION, 1987
Silver

This bowl was stamped with guitar wire in a spiral geometric shape. The background is hammered.

THE SWIRL, 1983
Silver

This early silver pot has swirl-shaped stampwork on a hammered texture. The mouth of the pot has a flared rim.

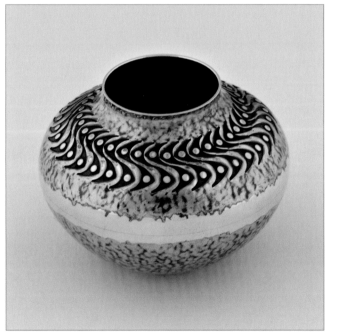

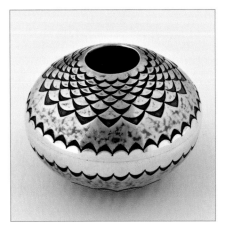 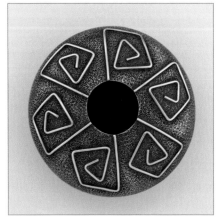 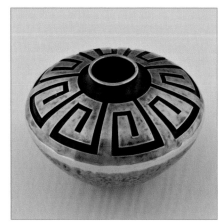

THE RIPPLE, 1981
Silver

The stamped designs on this pot are similar to those of carved pottery that Peshlakai has seen with "ripple water designs." It has a hammered texture background.

POT, 1982
Silver

This silver pot has six spiral designs made from appliquéd silver round wire. The background has a crosscut-tip hammered texture.

POT, 1979
Silver

Peshlakai remembered that he "had joy making this." The design consists of eight swirl patterns created with an overlay technique. The vessel has a flared opening, with a silver ring lining the rim. The background reveals a hammered texture.

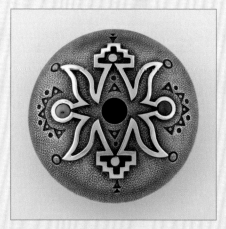

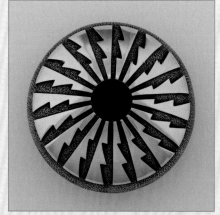

LIGHTNING BOLT, 1986
Silver

The lightning bolt for which this pot is named is appliquéd, and the vessel's background has a crosscut-tip hammered texture.

POT, 1998
Silver, fourteen-karat gold, coral, Sleeping Beauty turquoise

Sandfield was attracted to the finely detailed overlay of this pot. "The design pattern is more of Hopi or Zuni origin," Peshlakai says. "The combination of blue turquoise and red coral are more common in the early Navajo traditional jewelry. I did some jewelry with a turquoise and coral combination, especially shadow-box."

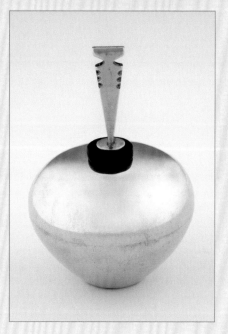

EMERGING ARROWHEAD, 1978
Silver, ebony

This piece takes its name from its arrowhead-shaped stopper. It was made using two pieces of silver soldered together, and Peshlakai left the vessel's surface smooth. A needle file produced carved notches that create the effect of an arrowhead.

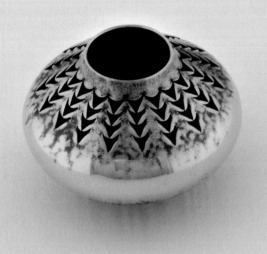

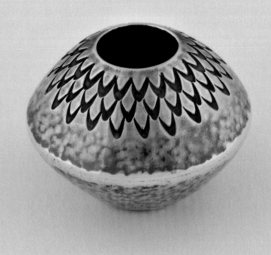

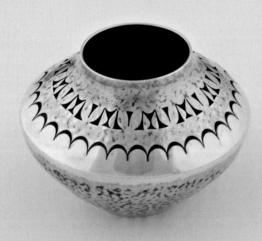

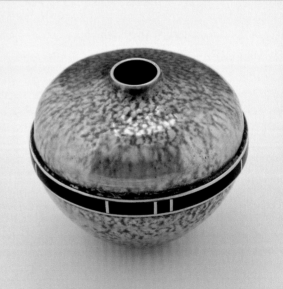

(clockwise from top left)

POT, c. 1984
Fourteen-karat gold

This miniature gold seed pot was commissioned by Sandfield through Martha Hopkins Struever in 1983 after Sandfield heard about Struever's gold pot by Peshlakai. A repeating tree motif radiates from the pot's neck to its rim.

THE ACORN SHELL DESIGN, 1983
Silver

The shape of the pot and the stampwork represent an acorn. The background has a hand-hammered texture.

POT, 1978
Silver, ironwood, gold

This early piece by Peshlakai has his briefly-used copyright stamp on its bottom, a finely hammered texture, and a flared neck.

POT, 1981
Silver

This vessel has a flared opening and stampwork on a hammered background.

PLAIN, UNDECORATED, *MOKUME-GANE*

BOWL, 1992
Silver

This hammered bowl is one of Peshlakai's few undecorated pieces. Both its lack of adornment and its shape make it unusual for the artist. Peshlakai explained that he "wanted people to see the fine details of how ball peen hammers portray the texture both inside and outside the bowl."

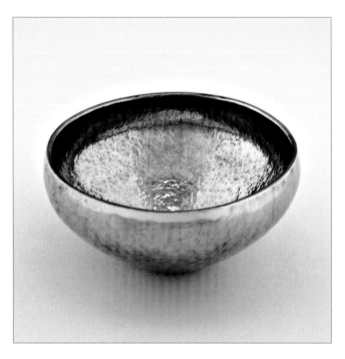

THE *MOKUME*, 1987
Silver and copper *mokume-gane*

"The metal [*mokume*] for this pot was sent to me while I was teaching at Western New Mexico University in Silver City. A collector wanted me to do a belt buckle for him. The extra piece was made into this pot. The metal is twenty-six layers of copper and silver, fused together and compressed to fourteen-gauge. *Mokume-gane* means 'wood grain metal' in Japanese."

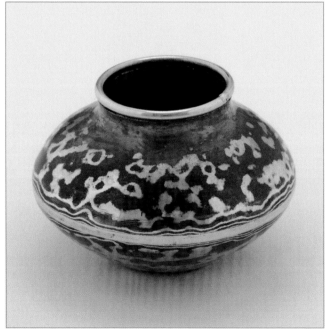

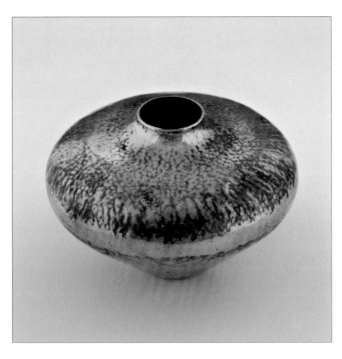

POT, 1986
Brass, copper

This was a "study piece" for Peshlakai, made while he was teaching at Western University in New Mexico. It is a hand-hammered pot with a flared neck.

VASE, c. 1980
Silver

This is one of Peshlakai's earlier experimental pieces. It is hammered and constructed of five pieces of silver to create a vase with a tall, flared neck and two handles.

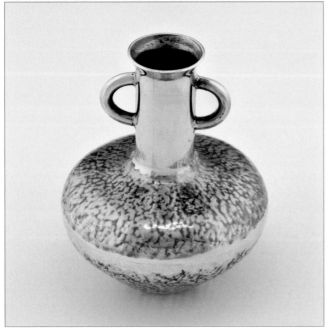

NON-CONTAINER SILVER OBJECTS

THE CUBE, 1988
Silver, coral

Commenting on this paperweight, Peshlakai wrote, "Sometimes I run into collectors or friends who ask me to create an unusual (bend-the-rule-type) piece. This cube paperweight was one of them." This is the second paperweight made by Peshlakai and was commissioned by Sandfield. The piece has no top or bottom. Each of its six sides was decorated using a different metalwork technique. Peshlakai enumerates them: 1) Sunshine stamped with light coral inlay, 2) Appliqué and stamped, 3) Wave design, 4) Overlay with a Mimbres bird design, 5) Number twenty-two-gauge guitar steel string impression, 6) Intricate, nine different stamps. In 1996, *The Cube* won a second place ribbon at the Inter-Tribal Ceremonial in Gallup, New Mexico.

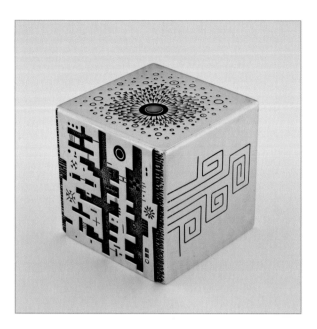

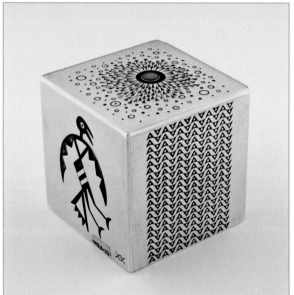

The Collection

VICTORIA ADAMS
Southern Cheyenne/Arapaho, b. 1950

Victoria Adams

POT, 2002
Silver, eighteen-karat gold

The four Morning Stars on Adams'
silver seed pot represent the four
directions and the four major stages
of life. ■

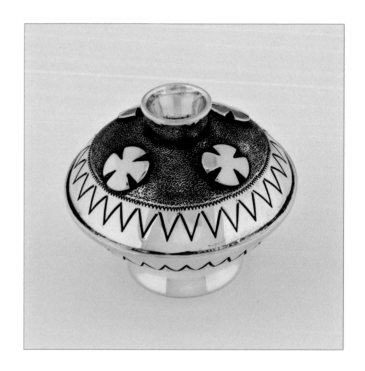

*Small objects of personal value have been worn, carried, or
kept in many types of medicine bundles longer than anyone's
memory … except for Mother Earth's. The objects I create
come from my life view, in which ritual, culture, ancient and
contemporary experiences play significant roles.*

— VICTORIA ADAMS

FLOYD BECENTI, JR.
Navajo, b. 1962

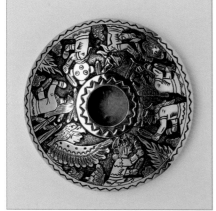

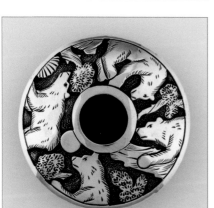

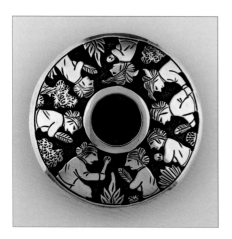

ZUNI NIGHTLY DANCER,
c. 2004-2005
Silver

Sixteen figures dance on an overlay pot that has stampwork throughout. Becenti is from Tohatchi, New Mexico. He attended Tohatchi High School and graduated in 1981. He also attended Western New Mexico State University. Becenti has been making jewelry since age nine. He learned silversmithing by watching his father. This pot has a diameter of 6 inches.

POT
Silver

This overlay pot has four bears on top and four on the bottom walking in a landscape of trees and bushes.

POT
Silver

Eight figures on the top and four at the bottom enliven this pot. ■

DARRYL DEAN BEGAY
Navajo, b. 1973

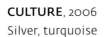

GENERATIONS, 2006
Silver, turquoise

Generations is made from two separate tufa castings. "The hands represent our ancestors and the petroglyphs tell ancient stories," says Begay. Sandfield commissioned the pot, the artist's first. "My seed pots are amazing to me," Begay says. "I see already the potential to make them more sophisticated. I can't wait to make the next one."

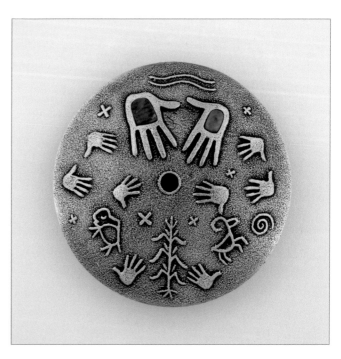

CULTURE, 2006
Silver, turquoise

Begay's second pot, *Culture,* won a third place ribbon at Santa Fe's Indian Market. "The turquoise is the main comet. The figures in the tail of the comet are our timeline. The corn stalk is the Blessing Way. The feathers are the Holy People." ◾

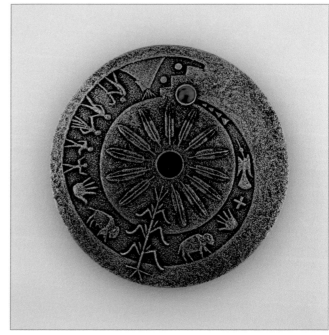

JERRY BEGAY
Navajo, b. 1958

—J.B—

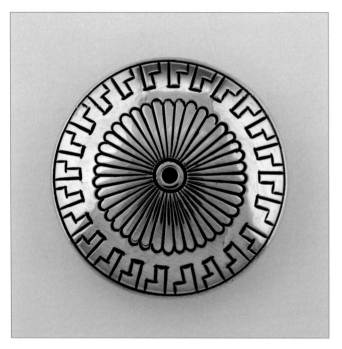

POT, c. 2005
Silver

Feathers radiate from the mouth of this vessel toward stepped-geometric designs.

POT WITH STOPPER
Silver, Chinese turquoise

A star-like pattern with eight geometrics embellishes Begay's pot with stopper.

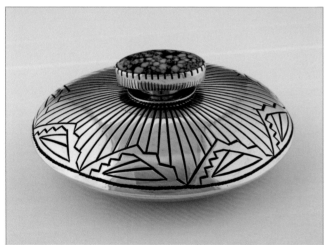

JERRY BEGAY

POT
Silver

This pot has stamped designs in a radiating, eight-pointed flower or sun design. There is also stampwork on the bottom.

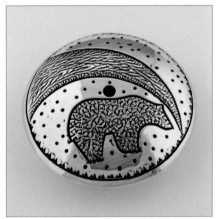

POT, c. 1994
Silver

This pot has a stamped bear design and the suggestion of a comet in the sky above the bear. ■

KENNETH BEGAY
Navajo, 1913-1977

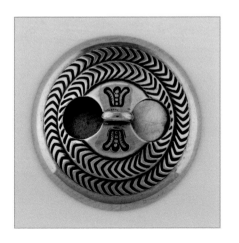

PILLBOX, c. 1955
Silver

Begay's unusual pillbox has a domed and moveable lid. It was made while the artist worked at the White Hogan in Scottsdale, Arizona. ■

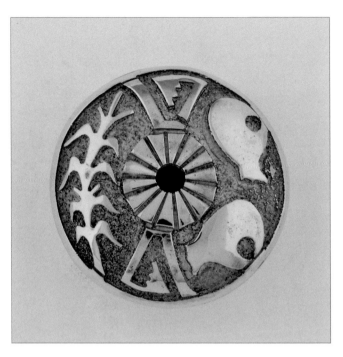

PHILBERT BEGAY
Navajo, b. 1969

Philbert Begay

POT, 2002
Silver

This tufa cast seed pot with bear and corn designs was originally made to be worn as a pendant. When Sandfield saw it at the 2002 Indian Market in Santa Fe, he asked Begay to remove the loop and transform the pendant into a pot.

POT, C. 2006
Silver

Begay's storyteller pot employs an overlay technique to create designs that include a hogan, a horse and rider, and images of Monument Valley. ■

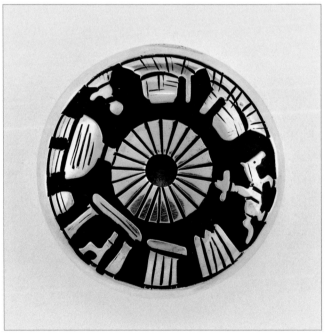

ARLAND F. BEN
Navajo, b. 1962

AFB

POT, 1998
Silver, fourteen-karat gold

This pot has overlay animal designs
and feathers.

POT, 1997
Silver, fourteen-karat gold

The design of Ben's silver and gold pot is
based on geometric shapes. ■

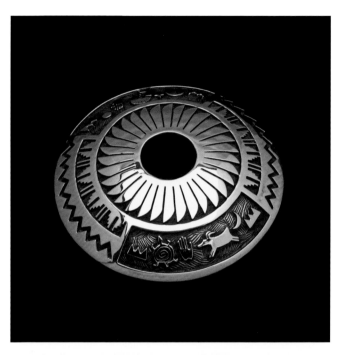

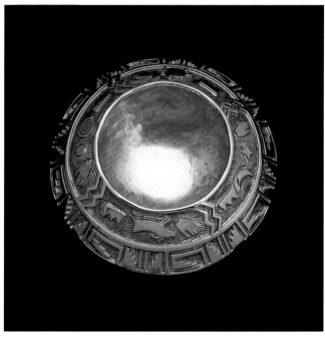

SAM BENALLY
Navajo, b. 1948

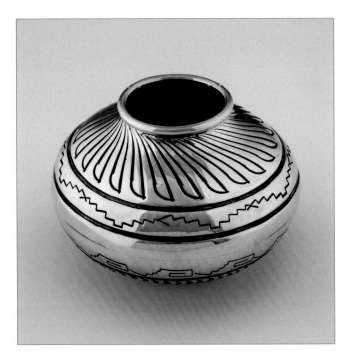

POT, 1997
Silver

A stamped feather design surrounds a lipped opening on this miniature. ■

GENE BILLIE
Navajo, b. 1969

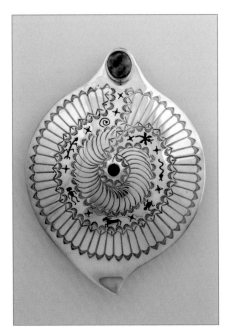

MOTHER EARTH, FATHER SKY, 2006
Silver, Yerrington turquoise

Sandfield commissioned *Mother Earth, Father Sky* after seeing Billie's larger pots at the 2006 Indian Market in Santa Fe. As the artist describes this 4-inch piece, "The turquoise represents the earth and the hole in the center is the passageway from the Third World into the Fourth World, where we now live. The Navajo (Diné) people believe we were transferred to this world with the help of the dragonfly … the front of the seed pot represents Mother Earth and all its creatures. The back of the pot resembles the Diné sand paintings of the sun used in ceremonies. The shape of the pot portrays the blanket protection of the creator." Billie hand-forges and manipulates sheet silver to make his sculptural miniature pots. He has made approximately 100 of them. ■

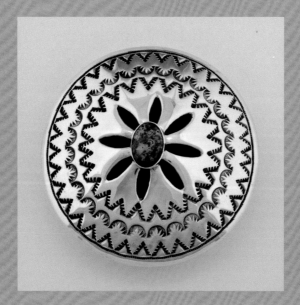

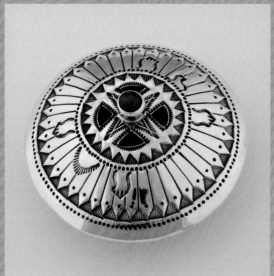

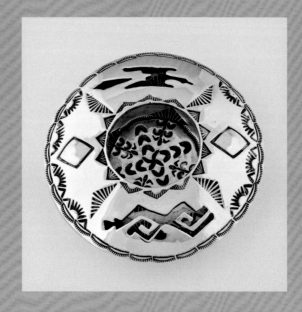

AARON BROKESHOULDER
Shawnee/Choctaw, b. 1972

Brokeshoulder

(facing page, top to bottom)

POT, 2000
Silver, turquoise

Brokeshoulder's silver seed pot incorporates both cutout designs and geometric stampwork. A turquoise stone crowns the top and forms the center of the cutout flower-like pattern.

POT, 2005
Silver, coral

This pot has a turtle overlay design and geometric feathers. It is stamped throughout.

POT, 2000
Silver

Not only is the exterior stamped with designs, but the inside of this pot is stamped as well, and there is repoussé on top. It has a cutout design of a peyote bird. ■

JEFFREY CASTILLO
Navajo

Jeffrey Castillo

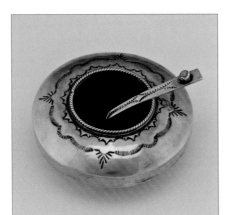

POT WITH SPOON
Silver, turquoise

This vessel has a twisted-wire rim and is accompanied by a spoon. ■

RIC CHARLIE
Navajo, b. 1959

POT, 2000
Silver, c. 1990
Silver, turquoise, lapis lazuli

This tufa cast pot has four lapis and four turquoise triangles around the opening and geometric designs throughout. The bottom has a freeform, flower-like shape. Its 4¼-inch diameter makes this pot one of the largest in the Sandfield collection.

THE MEDICINE, 2005
Silver

The Medicine is tufa cast with an eight-point star on top and a flower or sun design on the bottom. It was commissioned by Sandfield. ■

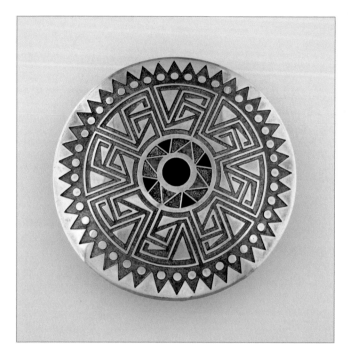

JARED CHAVEZ
San Felipe/Navajo/Hopi-Tewa, b. 1982

GERMINATION, 2006
Silver

Germination was commissioned by
Sandfield in 2006. This pot has an
antiqued gunmetal finish. ■

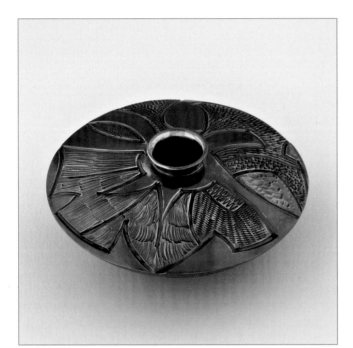

*"Having never made a seed jar, it took me some time to think of the
design. Eventually, I went with the concept of the creation of plant life.
The designs on the pot reflect the turmoil and struggle of seeds to become
fully grown plants. I also used the title as a play on meanings
for both the germination of seeds and the germination of
this very piece so it could come into existence."*

— JARED CHAVEZ (2006)

JENNIFER CURTIS
Navajo, b. 1964

Jennifer

POT, 1997
Silver

Curtis' pot is stamped on the top and bottom, and a continuous spiral design meanders around its plant-like shapes.

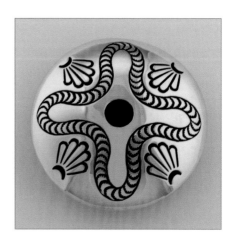

(facing page, clockwise from top left)

POT, c. 2000
Silver

This pot has stamped geometric feather designs on both the top and bottom.

POT WITH STOPPER, 2006
Silver, Kingman turquoise

This silver seed pot has a multi-layered feather design. The stopper is inlaid with a single piece of Kingman turquoise. This pot was commissioned by Sandfield.

POT WITH STOPPER, 2006
Silver

Curtis' large 3¾-inch silver pot has feather designs stamped on the top and bottom and a stopper with an eight-pointed design. Jennifer is the daughter of artist Thomas Curtis, Sr.

POT, 2006
Silver

The cylindrical shape seen here is unusual for a seed pot. There are stamped designs throughout. ∎

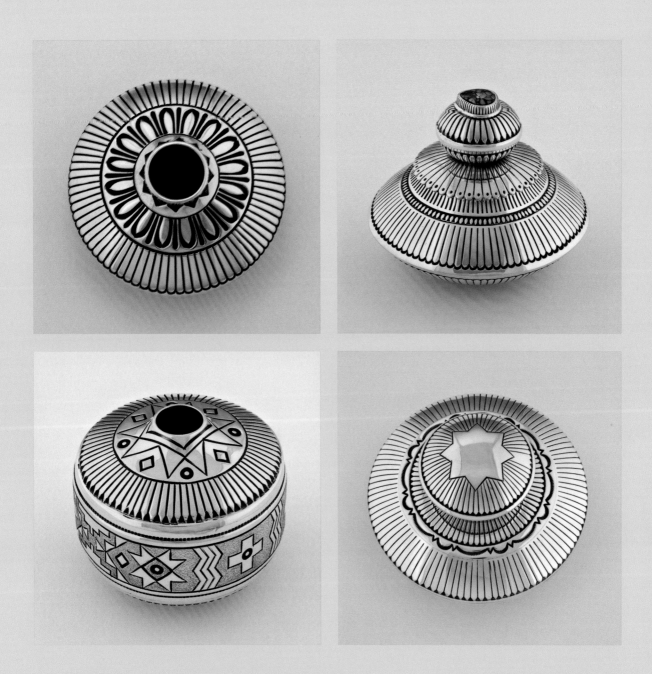

THOMAS CURTIS, SR.
Navajo, b. 1942

POT WITH STOPPER, 2006
Silver

Arrowhead-shaped designs radiate from the stopper of this vessel that was commissioned by Sandfield.

POT WITH STOPPER, 2006
Silver

This work, commissioned by Sandfield, is described by the collector as having a sunburst design. ■

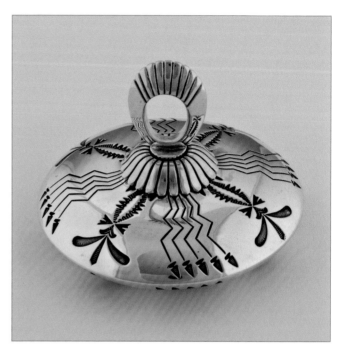

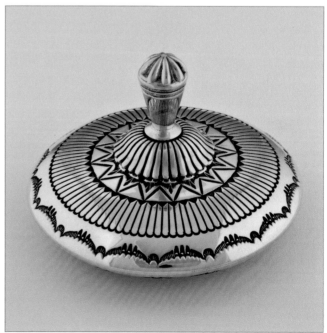

BERNARD DAWAHOYA
Hopi, b. 1937

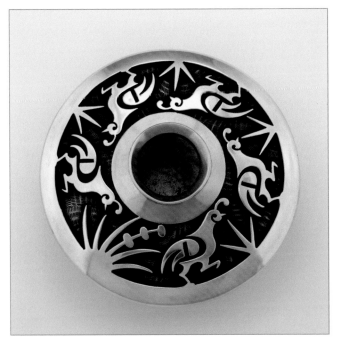

POT, 1980s
Silver

Dawahoya's seed pot incorporates Hopi overlay technique and a design of five quail and five plants. Dawahoya's pots were some of the first collected by Sandfield. The artist is among the second generation of artists to produce pots after Norbert Peshlakai.

POT, 1980s
Silver

This pot made with the Hopi overlay technique has seven Kokopelli, or Humpbacked Flute Player designs, and seven corn plant designs. ■

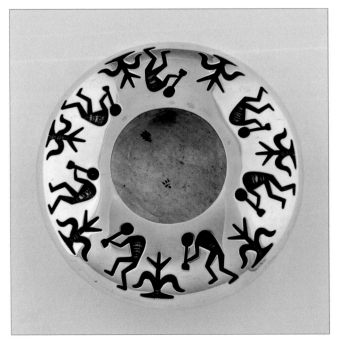

LEE EPPERSON
Cherokee, b. 1935

POT, 1990
Silver, coral, turquoise

Epperson used the lost wax casting
technique to make this vessel. ■

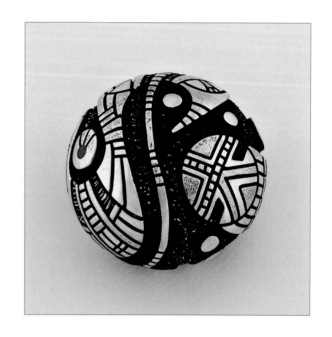

STANLEY FELIX
Navajo

POT, c. 2005
Silver

This pot has designs stamped on the top
and bottom. ■

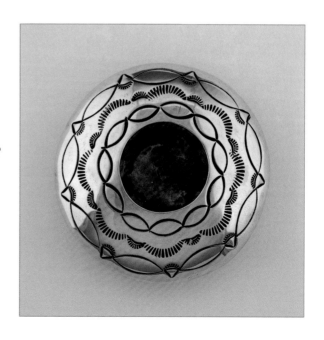

CONNIE TSOSIE GAUSSOIN
Navajo/Picuris, b. 1948

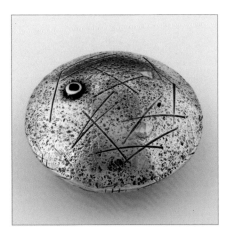

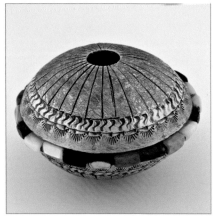

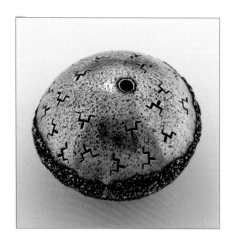

POT, 2002
Silver, fourteen-karat gold

This seed pot's opening is slightly off to one side. There are stamped designs on the top and bottom with four gold inlay pieces.

POT, 1997
Silver, turquoise, coral, mother-of-pearl, lapis lazuli, shell, ironwood

Gaussoin comes from a family of artists that includes silversmiths, painters, weavers, singers, and sculptors. Her family and clan heritage provides a basis for the design and development of her jewelry. She has exhibited widely and received awards at the Heard Museum Guild Indian Fair and Market, Santa Fe Indian Market, and Eight Northern Indian Pueblos. The family tradition promises to continue through the talents of Gaussoin's sons Jerry, David, and Wayne Nez, and her daughter Tazbah.

POT, c. 2004
Silver

Gaussoin used stamped designs and granulation on this pot. Collector Sandfield was attracted to the piece as "reflective of Gaussoin's newer, more contemporary work."

CONNIE TSOSIE GAUSSOIN

SHARING WITH MY RIO GRANDE PUEBLO NEIGHBORS, 2006
Silver

Avanyu, the water serpent, is associated with waterways, rain, and thunder. ■

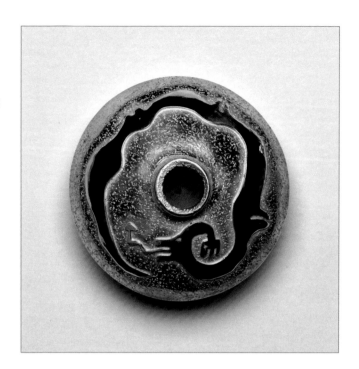

DAVID GAUSSOIN
Navajo/Picuris, b. 1975

DG

POT, 1998
Silver

This pot with its "Navajo knot" hair-tie design was cast by the artist in a class at the University of New Mexico, Albuquerque, with professor Comme De Jang. It is one of Gaussoin's first wax-cast pieces and displays a difficult-to-capture color in its patinated surface.

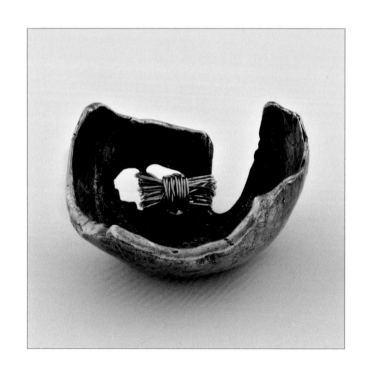

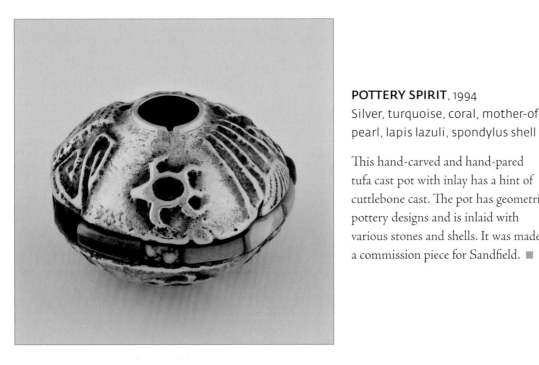

POTTERY SPIRIT, 1994
Silver, turquoise, coral, mother-of-pearl, lapis lazuli, spondylus shell

This hand-carved and hand-pared tufa cast pot with inlay has a hint of cuttlebone cast. The pot has geometrical pottery designs and is inlaid with various stones and shells. It was made as a commission piece for Sandfield. ▪

TAZBAH GAUSSOIN
Navajo/Picuris, b. 1992

NO HALLMARK

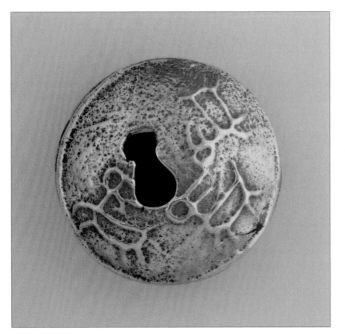

POT, 2004
Silver

A deer design decorates Gaussoin's first pot. ▪

STEVEN J. GUNNYON
Yakima/Chippewa, b. 1952

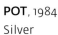

POT, 1984
Silver

Two buffalos and skulls are the main design elements for this pot by Gunnyon.

SPIRIT OF THE HORSE, 1986
Silver

Spirit of the Horse was raised from eighteen-gauge sterling sheet silver. The horse tracks symbolize abundance. The artist chose the design "primarily with Norman [Sandfield] in mind." ■

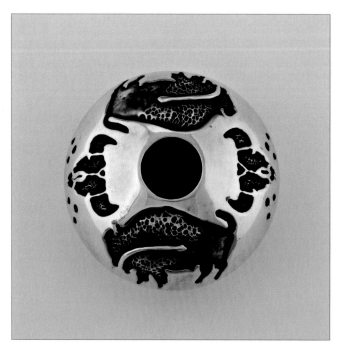

CODY HENDREN
Navajo/Santo Domingo, b. 1991

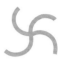

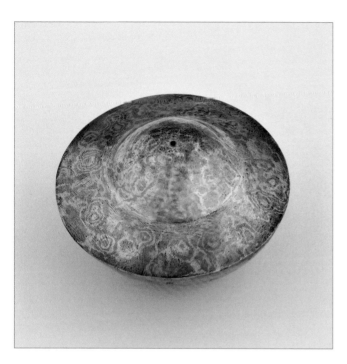

POT, 2006
Brass and copper *mokume-gane*

This pot was commissioned by Sandfield. ◾

Cody Hendren is the son of Shane R. Hendren, who is also represented in the Sandfield collection. Father and son create pots utilizing mokume-gane, a Japanese technique of combining non-ferrous metals on a molecular level and forging it to create random patterns. To Shane Hendren, mokume-gane and the Samurai tradition from which the technique comes exposed parallels between it and Hendren's own Navajo traditions: The individual participants dedication and honoring of their craft as well as all other phases of their life define the person.

SHANE R. HENDREN
Navajo, b. 1970

NAVAJO LAND, 2006
Silver and copper *mokume-gane*,
Blue Gem turquoise

Navajo Land was commissioned by
Sandfield. The artist undertook an
elaborate design, "patterned to represent
the milky-way galaxy, a place beyond
what we can see but we know is there. It
also is symbolic of the circle of life. The
turquoise represents the blue sky above
us. The patterning of the *mokume-gane*
on the lower portion has four
mountains representing the four
sacred mountains of the Diné. The
randomness of the bottom signifies the
underground, which then grows upward
into the patterns of the trees, plants, etc.
This vessel represents our actual world."

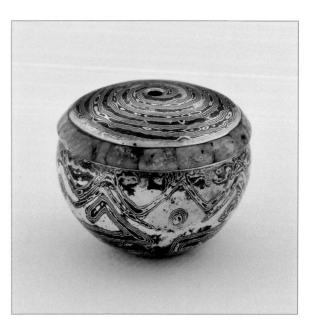

WATER IS LIFE, 2006
Silver and copper *mokume-gane*,
turquoise

The top portion of *Water is Life* is made
of copper and silver *mokume-gane*, and
according to Hendren "represents the
dry landscape of the Southwest. The
natural blue turquoise represents water
that sustains all life. The lower copper
and brass *mokume-gane* is patterned to
represent the bloom of the flower that
the water helps to create." ■

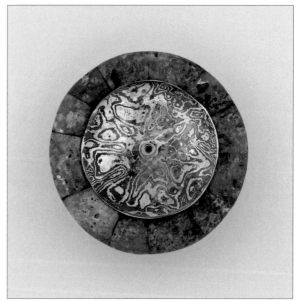

CARLTON JAMON
Zuni, b. 1962

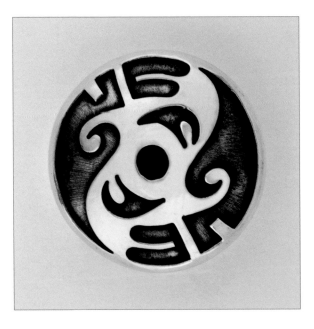

POT, 2000
Silver

This pot has overlay designs. ■

RAINEY JULIAN
Jicarilla Apache, b. 1956

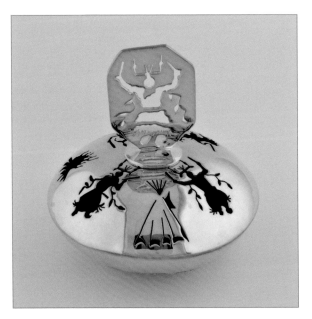

DANCE AROUND THE FIRE, 2006
Silver

Julian has made approximately twenty
miniature silver pots, beginning in 2002,
primarily using sheet metal and stamp
techniques. The artist values uniqueness
and sometimes adds beads to his work.
"Jicarillas are known for their baskets
and beadwork," he says. ■

DARRELL JUMBO, A.K.A. ELEPHANT MAN
Navajo, b. 1960

THE FISH POND, 2002
Silver, chrysoprase

The Fish Pond was Jumbo's second pot. His "first seven pots were flatter, now they are sunk deeper." According to the artist, "As long as art has no boundaries … I'm free to achieve my dreams and ambition in metal." Jumbo has made ten miniature silver pots to date.

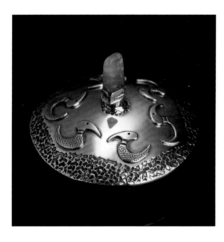

POT WITH BASE, 2001
Silver, leopard agate

Jumbo's first pot has stamped designs and leopard agate stones bezel-set on three-dimensional silver turtles. According to the artist, "I did not know there would be collectors drawn to these … for my pots I now usually create houses for them and I have also decided to stamp them inside with my trademark. I title all my pots—the only one untitled was this very first pot."

Jumbo began making miniatures to challenge himself and diversify his talents. He cites Norbert and Natasha Peshlakai and ancient Pueblo pottery as influences on his work.

I FOLLOW YOU, 2006
Silver, turquoise, coral

I Follow You was made using eighteen-gauge silver and stampwork. "Coral is the water side and turquoise is the land side," comments the artist. ■

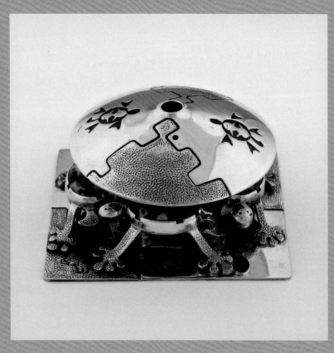

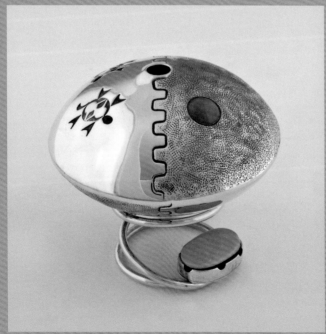

JULIUS KEYONNIE
Navajo/Hopi, b. 1964

POT, 2006
Silver, fourteen-karat gold

This pot has silver with gold details. Design elements include rain and an arrowhead. The pot was commissioned by Sandfield. ■

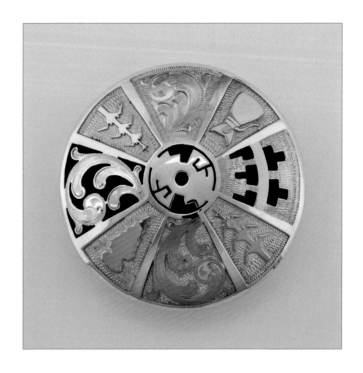

An aspect of collecting that gives me great pleasure is knowing the artists who actually made many of the pieces I own.

— NORMAN L. SANDFIELD (2005)

MICHAEL KIRK
Isleta/Navajo, b. 1949

POT WITH STOPPER, 1995
Silver, turquoise

This is the second pot made by Kirk. Since first making a pot in 1995, he has made six. The neck of the vessel represents a pueblo building. According to Kirk, "The top part of the pot is a feather motif carved and engraved with texturing around the feathers. The bottom of the pot is carved with a herd of buffalo stampeding."

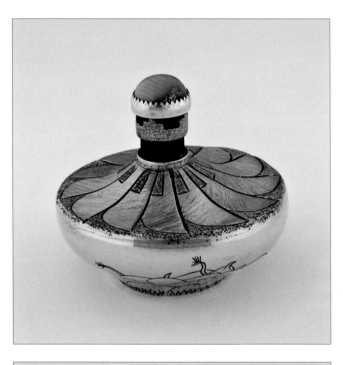

POT WITH STOPPER, 2006
Silver, turquoise

This pot has one piece of turquoise set on the top of the stopper and another inside the pot. Designs are stamped throughout. ■

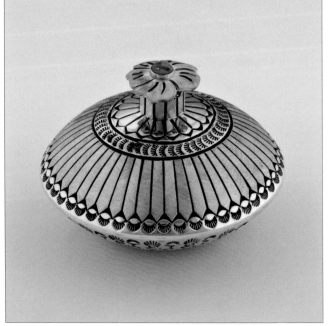

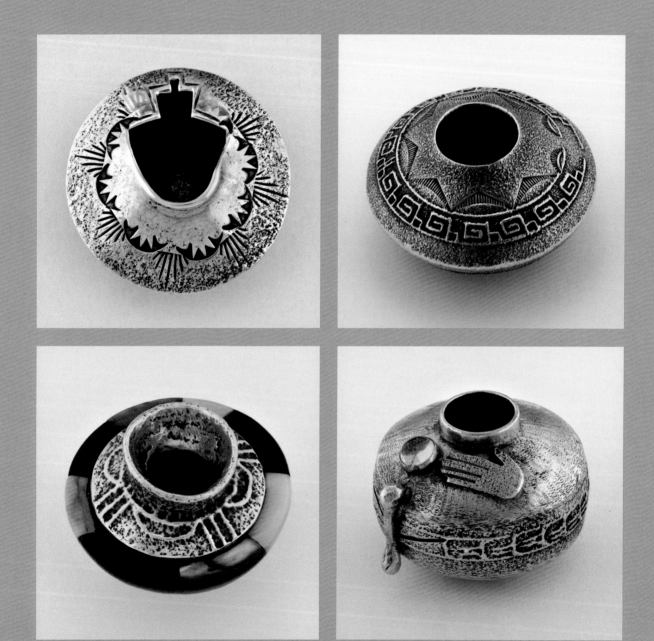

ANTHONY LOVATO
Santo Domingo, b. 1958

(clockwise from top left)

CEREMONIAL BOWL, 1992
Silver

Lovato's bowl was created by soldering together two pieces of stamped and domed flat tufa cast. A kiva step design comprises the opening. Lovato was influenced by his grandfather Santiago Leo Coriz, a metalworker who made traditional jewelry. Coriz learned casting from the same Hopi friend who taught Lovato. His mother, Mary, did Pueblo shell inlay work. Lovato uses silver and gold tufa cast and stampwork techniques with natural inlay materials and a variety of stones.

Lovato's work was exhibited in the 1997 Heard Museum exhibition *The Cutting Edge: Contemporary Southwestern Jewelry and Metalwork*, and in the accompanying catalogue curator Diana F. Pardue wrote: "Lovato is a member of the corn clan and uses corn imagery in much of his work. He was influenced by his former instructor and noted sculptor Allan Houser. He also credits Charles Loloma ... Lovato says of his work, 'It is important to me to hold on to the traditional stories. Through my designs in the large hollow-ware pieces, I am able to relate these stories in metalwork.'"

POT, 1992
Silver

This tufa cast pot has exterior geometric designs and a single buffalo motif in the interior.

DROP OF RAIN, 2006
Silver, citrine, fourteen-karat gold

Drop of Rain is tufa cast.

POT, 2001
Silver, turquoise, shell or coral, lapis lazuli, mother-of-pearl, ironwood

According to Lovato, silver "is a contemporary item for Pueblo people because metal was introduced by Spaniards." This tufa cast pot is inlaid with a variety of stones. ■

DUANE MAKTIMA AND ZELDA ABEITA
Laguna/Hopi, b. 1954 and Santo Domingo

NO HALLMARK

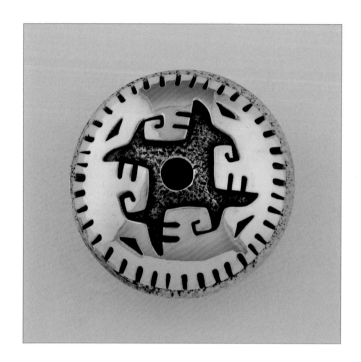

POT, 2000
Silver

This pot has four off-center geometrics radiating from its opening. Maktima recalls that this pot "was done with my assistant at the time, Zelda Abeita. She sometimes wanted me to give her challenges and this had to be one of those projects." ■

LINDA LOU METOXEN
Navajo, b. 1964

LLM

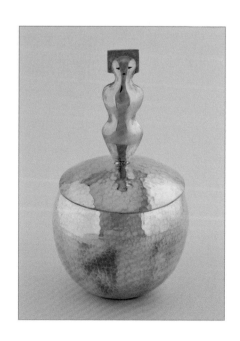

POT WITH STOPPER, 2006
Silver

Metoxen was commissioned by Sandfield to make this, her first silver seed pot. She was introduced to the form by Sandfield. The pot was shaped by a method called "raised metal," in which a flat disk of silver is sculpted as if making a pinch pot from clay. The silver is annealed, or heated, to make it malleable and then pounded into shape with a hammer. Metoxen describes the process: "Like most of my bigger pots, this miniature is formed from one sheet of silver. The process is called 'raising.' It is difficult to do with a miniature. I learned to raise metal in school. The figures on my silverwork are influenced by my mother's weaving and by the Yei figures of the Navajo. They represent the Holy People." ■

FRANK L. MORALES
Cherokee, 1931-2006

POT, 2005
Silver

The motifs incorporated on the top of this vessel were done using overlay technique.

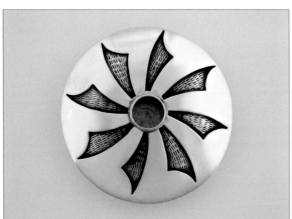

POT, 2005
Silver

This pot has an eight-pointed design element on the top and eight circle designs on the bottom. ■

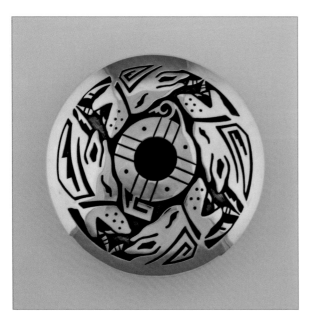

MERLE NAMOKI
Hopi, b. 1970

POT, 2006
Silver

Namoki's pot, commissioned by Sandfield, has "wolf designs, prayer feathers, and cloud symbols at the top meaning the four directions." The bottom of the pot has water wave designs. ■

L. EUGENE NELSON
Navajo, b. 1954

L.E. NELSON

STAR WARS SERIES, 1995
Silver, fourteen-karat gold, coral, lapis lazuli, turquoise

Nelson works in silver, gold, and turquoise. The process of hand-fabricating his sheet-and-wire constructions allows him to pursue a style that continually evolves. "Being a self-taught jeweler/artist and not having any of the major outside influences that usually occur through formal training or family trade involvement has allowed me not to feel any obligations or boundaries in designing my work. However, living in the Southwest, I cannot help but be influenced by the creativity of others, especially in Southwest architecture and contemporary three-dimensional art, and in the use of traditional materials of Southwest jewelry (primarily silver, turquoise, and coral). In addition, my background through high school in mechanical and architectural drawing and design has been the strongest influence in my work. This training emphasized the importance of precision, straight lines, and geometric shapes and angles."

This pot is the fourth in Nelson's Star Wars series. The "cracks" sawed into the bodies of the vessels prior to soldering reference the cracks that sometimes occur in clay pots during firing.

MELT-DOWN/WIRE-WRAP MINIATURE SEED POT WITH CRACK, 2006
Silver, fourteen-karat gold, oxblood coral, Sleeping Beauty turquoise, lapis lazuli

Nelson began his *Melt-Down/Wire-Wrap* pots in the late 1990s. This is the third of four in the series. Says Nelson, "My melt-down technique was first applied to pins/brooches. Because it could become more three-dimensional and more complex, I decided to try it on a more sculptural piece like a pot. The challenge in this technique is when to add the more heat-sensitive gold without melting the gold into the design."

The pot is of sheet-and-wire construction and the surface imprint was made with rice paper, scribed lines, reticulation, granulation, and fusion (application of silver dust to a heated surface to create a sandcast texture). The pot's pedestal has a highly reflective surface "to contrast with the dark pot that will sit on top of it." ■

AL NEZ
Navajo, b. 1959

AL NEZ

POT WITH STOPPER, 1986
Silver, lapis lazuli

Nez has created a small number of silver pots. In 1986, Sandfield purchased this piece that won a blue ribbon and best of division at Santa Fe's Indian Market.

POT WITH LID, c. 1990
Silver, turquoise, lapis lazuli

This pot is tufa cast with turquoise and lapis lazuli inlay around the sides. The top of the lid is adorned with a single piece of turquoise. ◼

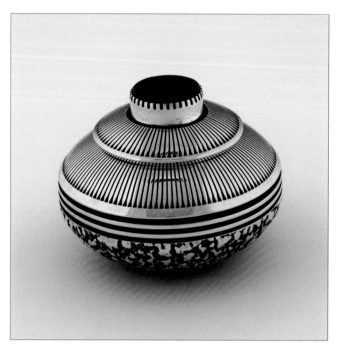

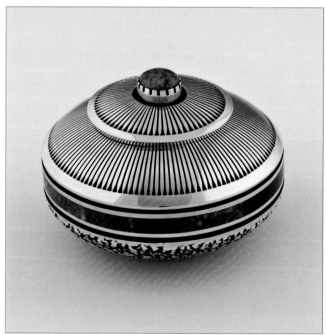

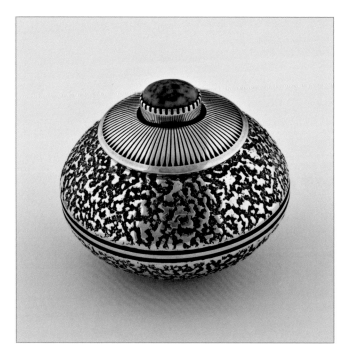

POT WITH LID
Silver, turquoise

This tufa cast pot has feather designs on a lid decorated with a single piece of turquoise. ■

LEONARD NEZ
Navajo

LEONARD NEZ
NAVAJO

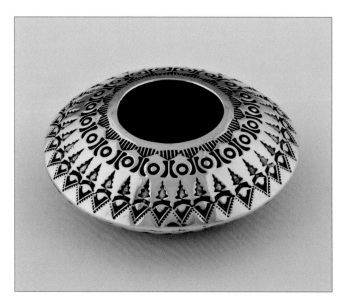

POT, 1998
Silver

This pot has overall stamped geometric designs. ■

AMMON MICHAEL NOFCHISSEY
Navajo, b. 1981

NOFCHISSEY

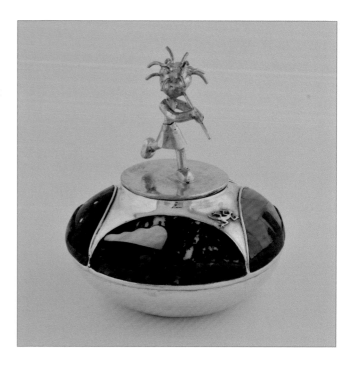

POT WITH LID, 2006
Silver, lapis lazuli, jet, fourteen-karat gold, jasper, mother-of-pearl

This pot with inlay has a three-dimensional Kokopelli on its lid. According to the artist, it was made using "two pieces fused together with an overlay of mesa skies. The lid is made of pure silver metal fabricated for a dancing Kokopelli (also fabricated) [to form] a unique design of a sun when looked at from above." A fourteen-karat yellow gold lizard embellishes the front. The pot represents Nofchissey's first foray into lapidary work.

Ammon Nofchissey is the son of Bobby Nofchissey, who is also represented in the Sandfield collection. The pot was commissioned by Sandfield. ■

BOBBY NOFCHISSEY
Navajo, b. 1951

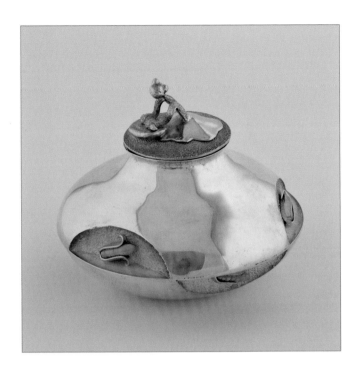

CORN GRINDING WOMAN, 2001
Silver, eighteen-karat gold,
turquoise

According to Nofchissey, "the construction of *Corn Grinding Woman* required a sophisticated technique of three-dimensional fabrication in .999 fine silver. I consider the small inverted ellipses to be a journey into the underworld of the Navajo creation story. I was inspired by my memory of my grandmother several days before Indian Market to tufa cast a tiny Navajo woman grinding corn in solid eighteen-karat gold. The tiny carved corns are all from one female variety of a light blue turquoise nugget ... the casting of her head and neck formed a perfect matate stone shape upon which she would grind her corn. I also tufa cast her body from her shoulders to her waist and then I fabricated her flowing skirt from a sheet of silver." In 2001, *Corn Grinding Woman* won a blue ribbon at the 55th Annual Navajo Nation Fair. ■

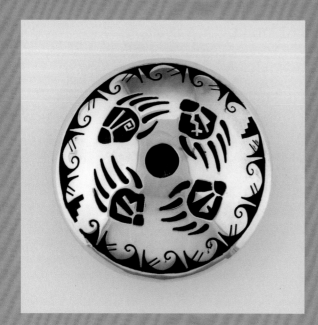
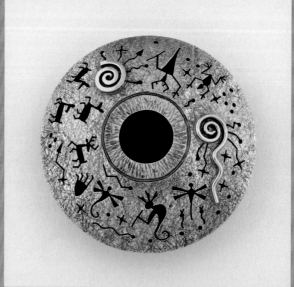
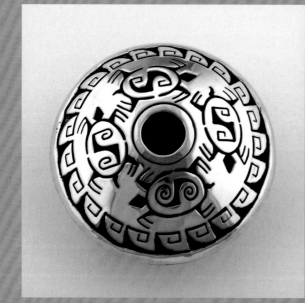
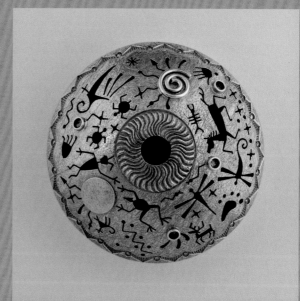

MYRON PANTEAH
Zuni/Navajo, b. 1966

(clockwise from top left)

RAIN DANCER, 1997
Silver

This is one of Panteah's first miniature pots. The design consists of overlay bear paws with lightning and water symbols and stamped designs on the bottom of the pot. The vessel's overlay technique employs sixteen-gauge on eighteen-gauge silver. The bottom is sixteen-gauge silver.

Panteah cites as influences Norbert Peshlakai, Charles Loloma, Jesse Monongya, his father Martin Panteah, and artists' work that he has seen in *Arizona Highways*. Having made 150 miniature pots, he continues to enjoy the challenge to scale down his work.

POT
Silver, fourteen-karat gold

This pot has cutouts including deer, dragonflies, and turtles.

POT
Silver, fourteen-karat gold

This piece has cutouts and stamped designs representing horses, dragonflies, animal tracks, clouds, butterflies, and other creatures.

POT
Silver

Designs used on this overlay pot include turtles and dragonflies.

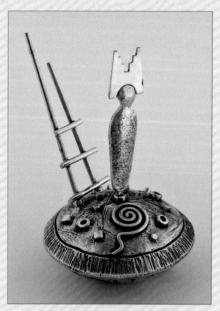

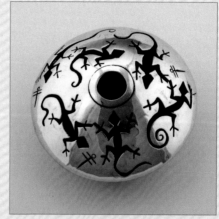

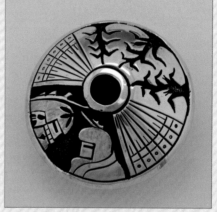

MYRON PANTEAH

POT
Silver

Appliquéd circles, squares, spirals, stamped clouds, lightning, and tadpoles embellish this vessel. A human form rises from the pot, and a removable ladder is inserted into two holes.

POT
Silver

This pot has six overlay lizards on the top and bottom. There are also stamped designs of frogs, tadpoles, and dragonflies.

POT
Silver

Panteah's pot with three corn stalks and katsina figures is made using the overlay technique. It includes stamped designs of turtles, clouds, dragonflies, and corn. ■

ALLENROY PAQUIN
Jicarilla Apache/Zuni, b. 1954

NO HALLMARK

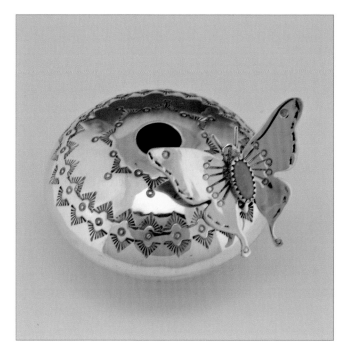

POT, 2007
Silver, turquoise

This pot with stampwork has a removable butterfly pendant that can also be worn as a brooch. ▪

When Allenroy Paquin inherited his father's silversmithing tools and lapidary equipment, as well as the Zuni tradition of jewelry making, he decided to pursue the art of silversmithing. Some of his objectives are to "inform and educate students and the general public about the history and differences of Indian tribes; to provide an example of the beauty and talent of the American Indian; and to be an advocate to having healthy drug and alcohol-free lives."

— ALLENROY PAQUIN

AARON PESHLAKAI
Navajo, b. 1983

POT, 2006
Silver

This was a study piece for Peshlakai, as he learned to shape and flare the silver. It has a rusted hammered texture.

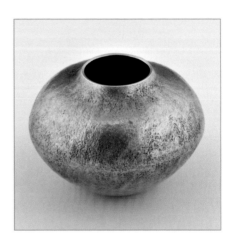

(facing page, clockwise from top left)

THE BUCK AND THE SUN, 1997
Silver, coral

The Buck and the Sun has an appliquéd sunray design radiating out from the mouth and a piece of coral to represent the sun. The landscape is filled with design elements including a buck, rocks, and trees. The background of the pot is a punch-tip hammered texture.

RABBIT IN THE FIELD, 1994
Silver

Rabbit in the Field bears four stamped rabbits among other designs such as horseshoes.

POT, c. 1997
Silver

This was Peshlakai's first pot. He used his father Norbert Peshlakai's rabbit and dragonfly stamps for the designs seen here.

THE MORNING STARS, 2006
Silver, coral

The mouth of *The Morning Stars* has a large cutout in the shape of a star. Smaller star-shaped designs are stamped throughout the body of the pot. It has a punch-tip hammered texture. ■

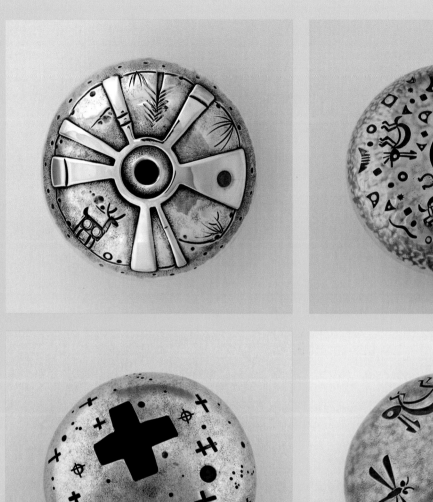
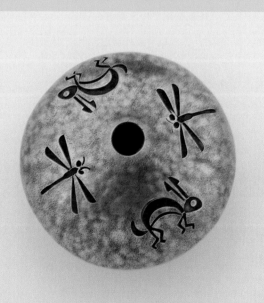

KENNETH PESHLAKAI
Navajo, b. 1968

NO HALLMARK

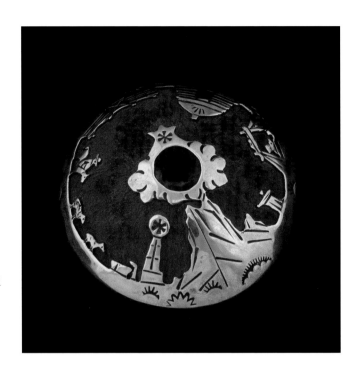

POT, 2002
Silver

The top half of this silver seed pot has a storyteller design, and the bottom half has a feather design. The entire bowl was done using overlay. Peshlakai made his first silver pot in 2000 after seeing those made by Navajo artisans such as Norbert Peshlakai. He says he "enjoyed working on a three-dimensional piece" and has "done maybe two or three more pieces, mostly as gifts and special orders." ■

"I have not seen that many books or histories of silver seed pots except when I read an article on Norbert Peshlakai. Clan-wise, Norbert is probably my uncle knowing that he is of the Salt Clan as am I."

— KENNETH PESHLAKAI

NATASHA PESHLAKAI
Navajo, b. 1981

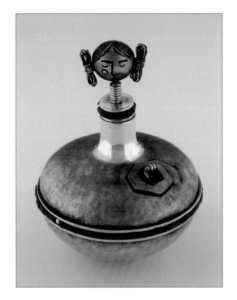

THE POTTER, 2006
Silver, coral, fourteen-karat gold
wire, gold beads

The stopper for *The Potter* is in the
shape of a woman's head and neck. Her
hair is made of gold wire. The body of
the pot curls around to form her arm
and hand. The pot has a punch-tip ham-
mered texture and a flared rim.

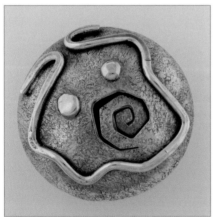
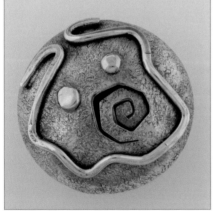

POT, 2002
Silver, fourteen-karat gold

Peshlakai first participated in Santa
Fe's Indian Market in 1992. This work
was purchased by Sandfield during the
2002 market. Natasha is the daughter of
Norbert Peshlakai.

POT, 2004
Silver, fourteen-karat gold

The top of this pot is adorned with
a three-dimensional rabbit, stamped
rabbit tracks, three drops of gold, and a
three-dimensional flower with a delicate
gold center. ■

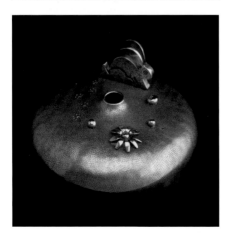

DON PLATERO
Navajo, b. 1954

POT, c. 2006
Silver

This pot has an avanyu, or water serpent design around the circumference, and the rim of the mouth is notched out as part of the overall design.

POT WITH SPOON, 2005
Silver, turquoise

Stampwork covers this pot and its matching spoon with turquoise inlay. ▪

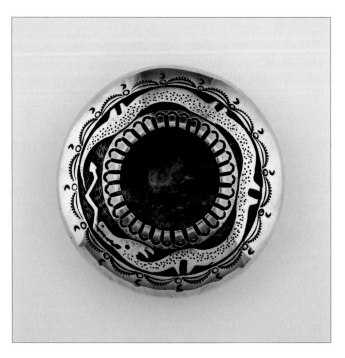

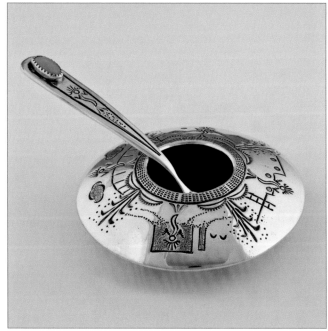

PAUL PLATERO
Navajo, b. 1955

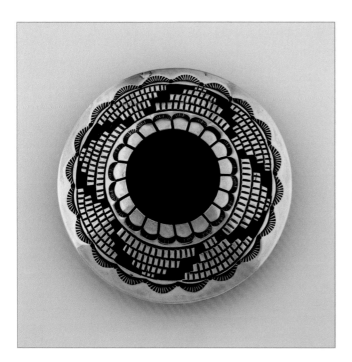

POT, 1994
Silver

This silver seed pot is made using an overlay technique with geometric step designs. ■

STARLIE POLACCA III
Havasupai/Hopi-Tewa, b. 1948

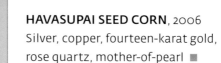

HAVASUPAI SEED CORN, 2006
Silver, copper, fourteen-karat gold, rose quartz, mother-of-pearl ■

CHARLENE L. REANO
San Felipe/Santo Domingo, b. 1966

Charlyn

POT, c. 1998
Silver

Reano's pot has traditional Santo Domingo animal pottery designs of a buck and doe. It was made as a commission piece for Sandfield.

POT, 1998
Silver

This silver seed pot has four birds in the style of traditional Santo Domingo pottery designs. ■

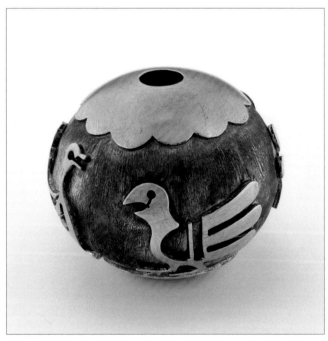

DANIEL SUNSHINE REEVES
Navajo, b. 1964

SUNSHINE REEVES

(clockwise)

POT
Silver

This pot is stamped heavily throughout. Daniel Sunshine Reeves is half brother to silversmiths Gary Reeves and the late David Reeves.

POT, 1997
Silver

This pot has stamped geometric designs throughout.

POT WITH STOPPER, 2005
Silver, turquoise

This piece has an elaborate stopper, fine turquoise inlay, and stampwork throughout. It was commissioned by Sandfield. ■

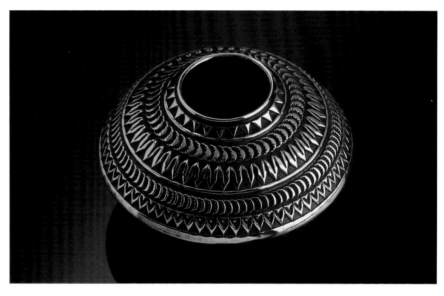

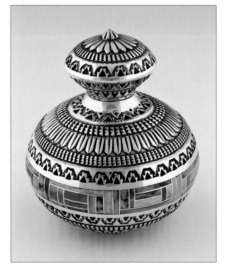

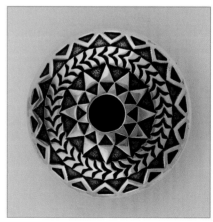

GARY REEVES
Navajo, b. 1962

GARY REEVES

POT, 1990s
Silver

To make this 3-inch pot, Reeves
began with a round cutout, applied
chisel work, and "textured it with
sandpaper and a rolling mill to give it
an old-style look, then used steel-wool
to buff."

POT
Silver, turquoise

Twenty-one turquoise stones surround
a feather design radiating from the
mouth of this pot. ■

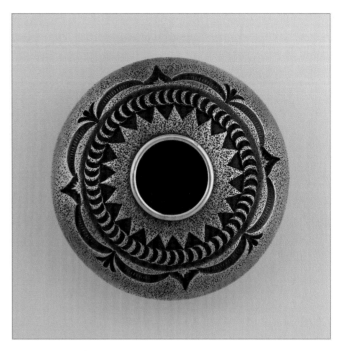

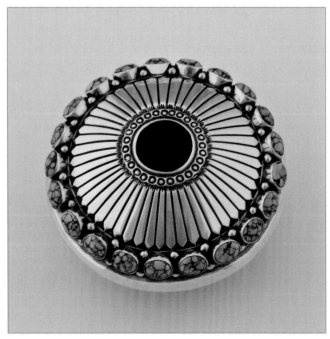

ALEX SANCHEZ
Navajo/Zuni, b. 1969

Alex Sanchez

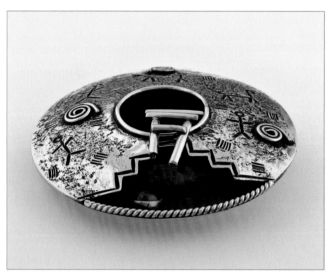

POT, 2004
Silver, turquoise

According to the artist, this pot represents life. There is a three-dimensional pueblo inset into the side opening, and one piece of turquoise is set next to the opening. Stamped human figures and a horse are incorporated into the design.

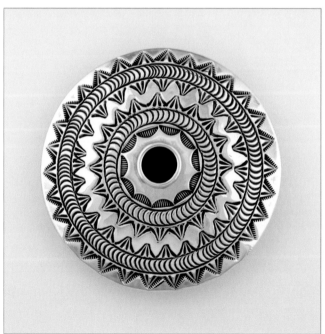

POT, 2006
Silver

Sanchez's pot has stamped geometric designs.

ALEX SANCHEZ

PETROGLYPHS, 2006
Silver, coral

According to Sanchez, the designs
on *Petroglyphs* represent raindrops,
the harvesting of corn, the Morning
Star, and a bear to signify strength,
guidance, and direction. This pot was
a Sandfield commission.

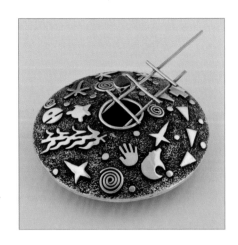

POT, 2006
Silver

Sanchez describes his vessel as being
based upon Navajo basket designs
representing wellness and life. ■

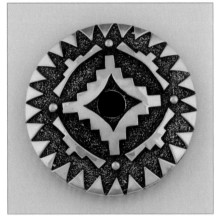

PHILLIP SEKAQUAPTEWA
Hopi, 1948-2003

POT, 1999
Silver

Sekaquaptewa's silver seed pot has
stampwork depicting corn and
Kokopelli in the style of Mimbres
pottery designs. ■

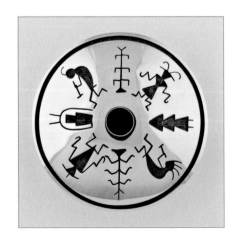

HOWARD SICE
Hopi/Laguna, b. 1948

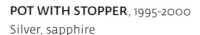

POT WITH STOPPER, 1995-2000
Silver, sapphire

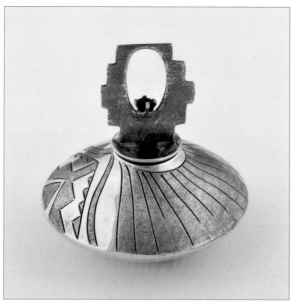

Sice's 2-inch diameter pot with lid is hand-engraved with Hopi pottery symbols. A sapphire is set on the stopper, the first faceted gemstone Sice used in his designs. Sice credits his wife Patricia for encouraging him to begin making silver pots in 1985; he has made approximately 100 miniature vessels since then.

POT WITH STOPPER, c. 2003
Silver, malachite, garnet, fourteen-karat gold

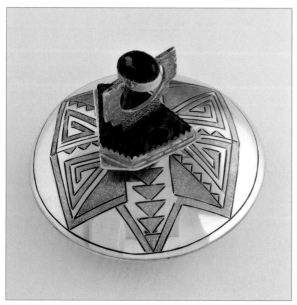

This pot has a stopper with malachite and garnet stone embellishments. The pot itself has been incised and stamped with intricate designs.

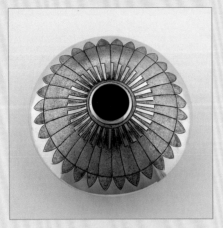
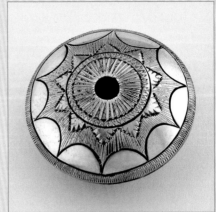
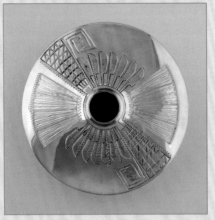
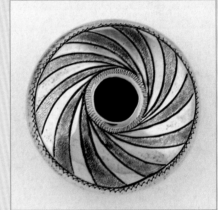

HOWARD SICE

(clockwise from top left)

POT, 1989
Silver

This is a sun represented by eagle
feathers. The texture is a stipple.

POT
Silver

An engraved swirl design radiates from
the mouth of this pot by Sice.

POT, c. 1992
Silver

The designs used here are cloud shapes,
with a sun at the opening.

POT, 2006
Silver

This pot has incised feather designs. ■

LORENZO TAFOYA
Santo Domingo, b. 1951

L Tafoya

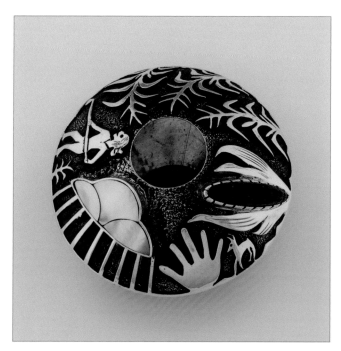

HARVEST TIME, 2002
Silver, lapis lazuli, mother-of-pearl, turquoise

Harvest Time is a fabricated silver overlay pot on a reticulated surface with oxidation. The pot depicts fruits of the growing season, blue corn inlaid with lapis lazuli, deer, and a rain symbol inlaid with mother-of-pearl. The bottom of the pot depicts trout, flowers, corn, and a turtle (for longevity), inlaid with turquoise. It won a second place ribbon at the 2002 Indian Market in Santa Fe.

Tafoya began making miniature silver seed pots while studying planishing techniques with Duane Maktima at the Institute of American Indian Arts in Santa Fe. His work reflects the influence of his father Santiago Tafoya, his interest in Pueblo and Spanish cultural history, his love of the outdoors, and his study of the pottery collection at the School of American Research in Santa Fe.

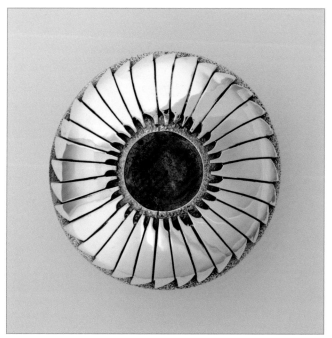

FEATHER SEED POT, 2004
Silver

This seed pot has a Santa Clara-style feather design and overlay on a reticulated surface.

LORENZO TAFOYA

(clockwise from top left)

DISCOVERY OF PARADISE, 2000
Silver, fourteen-karat gold,
turquoise

The piece is fabricated silver and gold overlay on a reticulated surface with stampwork. Silver filings fused to the pot create the textured surface. It depicts the introduction of Spanish conquistadors to Pueblo culture.

POT, 1999
Silver, fourteen-karat gold,
Sleeping Beauty turquoise

The flower on this pot is made in the style of Santo Domingo designs used on clay pots. There is stampwork on the bottom and the lip of the opening with four Sleeping Beauty turquoise pieces depicting the four directions and four seasons.

CONQUISTADOR JOURNEYS, 2003
Silver, fourteen-karat gold

According to Tafoya, "This pot depicts the search for riches by conquistadors and the Christian influence they left behind in Pueblo culture. The sun symbol is made of gold. The pot is silver overlay on a reticulated surface. The motifs are hand-cut and there is stampwork on the reticulation and the corn symbols."

BOWL, 2006
Silver, fourteen-karat gold,
turquoise

Tafoya constructed this piece playfully from scrap and leftover cutouts on an unfinished pot, which was originally intended to be a miniature goblet. ■

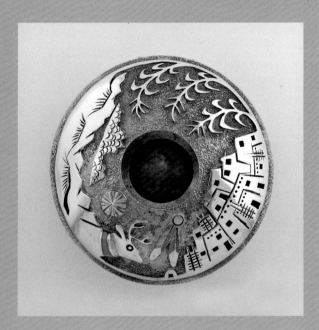
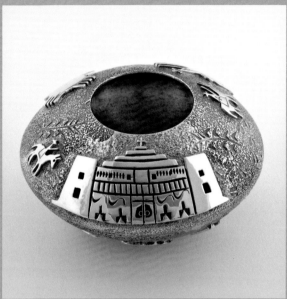
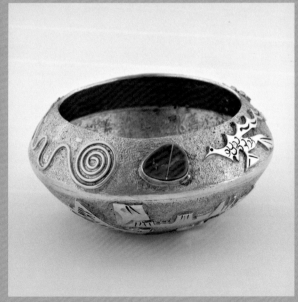
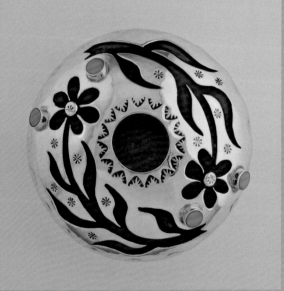

JASON TAKALA, SR.
Hopi, b. 1955

POT, 1997
Silver

This pot by Takala incorporates Hopi overlay in a Mimbres-style feathered stamp design around the opening, with a star-shaped design that increases in size toward the edge of the seed pot. The designs were drawn on the silver with templates and a scriber. The pot won a second place ribbon at the 1997 Indian Market in Santa Fe.

POT, 1993
Silver

Takala made his first silver seed pot in August 1991, and has made twelve to date. According to Takala, "The butterflies and flowers were drawn right on the silver and cut out with a jeweler's saw, soldered and formed to its dimension. There are three sheets of silver. The designed piece is overlay and the bottom is formed to accommodate the two parts."

POT, 1998
Silver

According to Takala, "The design on this pot is I'itoi, or 'the man in the maze, and represents the emergence of the man into the new world and his migration."

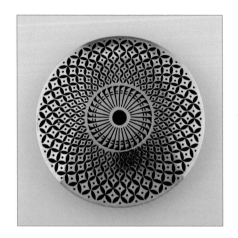

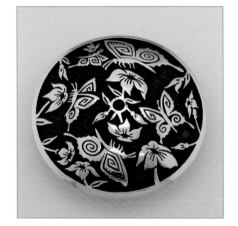

POT, 2002
Silver

Takala made this vessel using an overlay technique for the feathers and stepped designs. "From the center are snow clouds coming out with the wave patterns that are the movements of the clouds. As the clouds move, they roll—they do not move in one solid motion. The feathers are our way of praying for rain to come and water our crops."

POT, 1998
Silver

The lizards were drawn on the silver with a scriber, cut out with a jeweler's saw, overlaid on another sheet of silver, then formed and soldered to the bottom silver, which is also formed to accommodate the top portion.

INTERLOCKING PARROTS, 2005
Silver

Interlocking Parrots, according to Takala, "was made for the annual show at Estes Park, Colorado. There are eight parrots flowing through each other and interlocking with one another. This was created from the beauty of their colors, their graceful flights, and their way of life to live as one family." ■

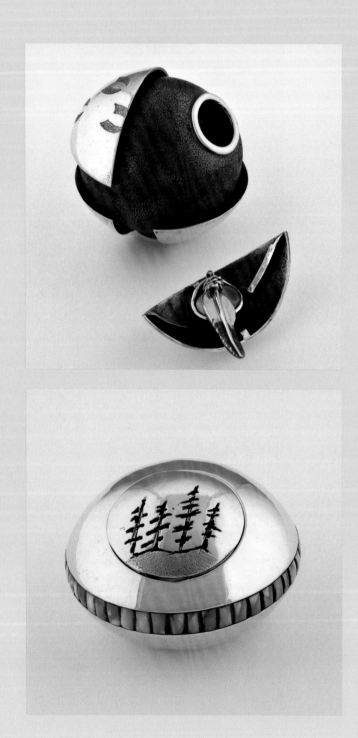

TCHIN A.K.A. TONY CHIN
Narragansett/Blackfoot, b. 1946

MEDICINE WHEEL, 1988
Silver, wampum (Quahog shell)

When the lid is on this pot, it forms a Medicine Wheel design. A wampum shell is set inside the lid that also has a sterling silver eagle feather dangle. The inner wall is textured and the outside wedges are polished. Tracks around the surface of the pot signify buffalo. According to the artist:

Medicine Wheel, also called the Indian Cross, is as significant a symbol as any other that people the world over developed to signify religious meaning, i.e. the crucifix, crescent moon and stars, and the Star of David. It is as philosophical as the Yin Yang symbol from Asia. The Medicine Wheel illuminates the nature of religion and morality. It symbolically represents the entire creation, 'The Magnificent Mystery' … the mystery of the universe … the mystery of life … the energy source of all things. The Medicine Wheel is first a circle (the symbol of harmony and unity of all things). Within the circle is a cross, which represents the seven directions. They are the four cardinal points, the zenith, the nadir, and where all these powers come together, the center. It is also the center where the first human came up from the underworld. Each direction speaks of a season, a color, time, sex, emotion, and an animal. The word 'medicine' when used by Native people actually means spiritual strength, power. Each nation attributes their own values to the meanings of the four directions, most especially because of the geographical location of the nation.

In 1989 this pot won a second place ribbon at Santa Fe's Indian Market. Tchin has made five miniature silver pots and he sometimes creates them with a unique surprise inside.

POT WITH LID, 1991
Silver, turquoise, coral, wampum (Quahog shell)

This domed pot has designs made by cutting away the tree motifs. The inside of the pot lid is the sacred wampum (Quahog shell). The sides of the pot are set with wampum, turquoise, and coral circling the container. This is one of Tchin's earliest pots "honoring the indigenous people of the Northeast Atlantic Coast." ■

EVERETT TELLER AND MARY TELLER
Navajo, b. 1956 and Navajo, b. 1955

POT WITH STOPPER, c. 1997
Silver, turquoise

This pot has stamped bear designs, Kokopelli, and turquoise inlay. A three-dimensional bear forms the stopper.

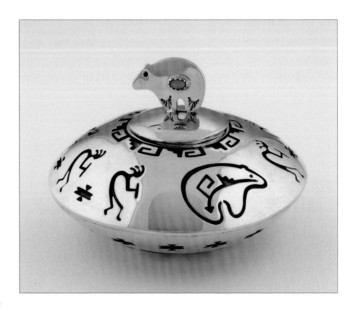

MICRO-POT, 1970s
Silver

According to the artists, "This miniature silver pot is for collection and display purposes. The stamping and the size of the piece indicate the work and craftsmanship, even though the pot itself is small. We are pleased that one of our works has ended up with a collector who appreciates such works." ■

PAUL LEO THOMAS
Akimel O'otham, b. 1923

POT, c. 1990s
Silver, coral

The design on this miniature silver seed pot consists of human figures and lizards with inlaid eyes of coral.

POT WITH STOPPER, 1997
Silver, lapis lazuli

Thomas' stoppered pot has stamped geometric patterns with lapis lazuli inlay. ■

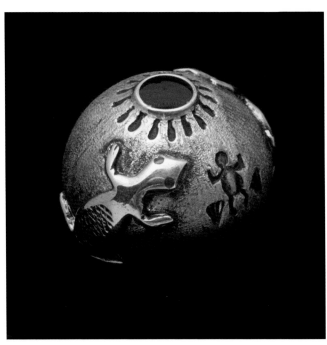

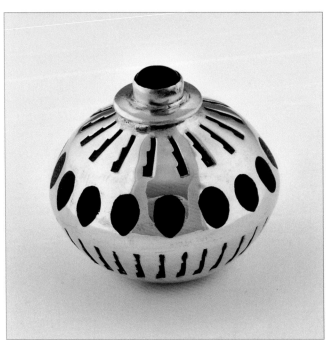

W. TRACY

W. TRACY

POT, c. 2005
Silver

This pot is stamped with eight diamonds on the top and bottom, with other stamped designs between. ■

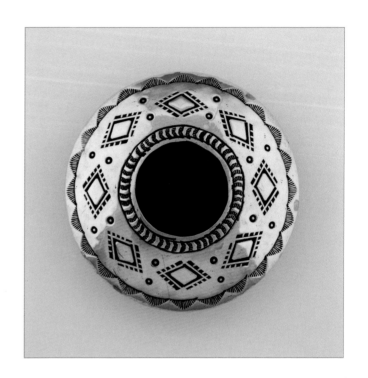

LYNDON B. TSOSIE
Navajo, b. 1968

LYNDON

POT, 2006
Silver, turquoise, coral, mammoth ivory

Tsosie began making pots in 1997 and since has made seventeen miniatures. This is the first he has made this small. It was commissioned by Sandfield. ■

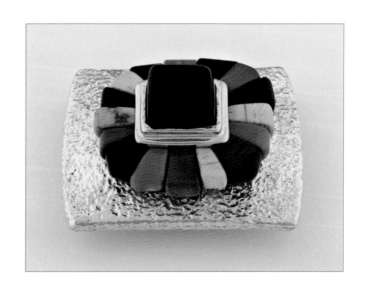

WHITE BUFFALO, A.K.A MIKE PEREZ
Comanche/Mexican, b. 1946

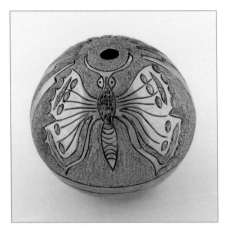

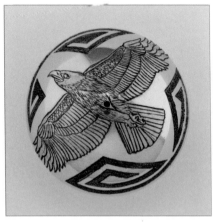

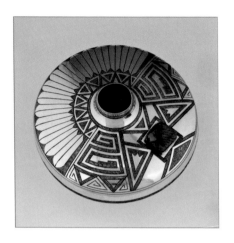

POT, 1978
Fourteen-karat gold

White Buffalo is one of the earliest makers of miniature silver seed pots represented in the Sandfield collection. He began painting and sculpting in 1970. His jewelry took thirty-six first place awards in 1974 at expositions in California, Arizona, and New Mexico. At the 1975 Gallup Inter-Tribal Ceremonial in New Mexico, he won the Handy and Harman Merit Award, a coveted prize given by the largest silver refiners in the world.

POT, 2002
Fourteen-karat gold

This pot has an eagle and feather design.

POT, 1990
Silver, turquoise

This large pot with a 6-inch diameter was incised with designs and has a piece of turquoise inlaid on the top. ■

JEROME BEGAY WHITEHORSE
Navajo, b. 1957

-JBW-

POT, c. 2005
Silver

This pot has feather motifs radiating from the mouth of the pot. Stamped zigzag designs continue around the top half of the pot. ■

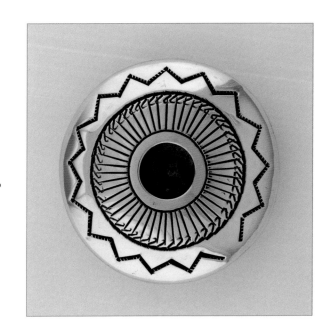

JEROME BEGAY WHITEHORSE AND ELSY WHITEHORSE
Navajo, b. 1957 and Navajo, b. 1957

JBWEW

(facing page, top to bottom)

POT, 2006
Silver

This pot has a textured top with linear designs throughout, and the bottom has stampwork as well.

POT, 2006
Silver

This pot has a textured top and stampwork on the bottom. ■

ELIZABETH M. WHITMAN
Navajo, b. 1936

E.M.W.

POT, c. 2004
Silver, turquoise

This pot is very similar to one made by Whitman's son Wesley K. Whitman, who is also represented in the Sandfield collection. This pot has four turquoise stones set amid stampwork. ■

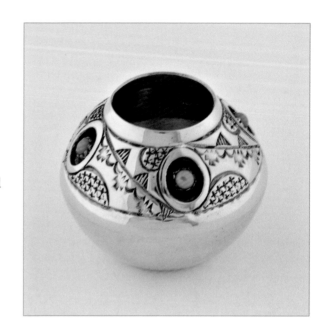

WESLEY K. WHITMAN
Navajo, b. 1963

W.K.W.

POT, c. 2004
Silver, coral

This silver seed pot has four inlaid coral pieces placed among stampwork. ■

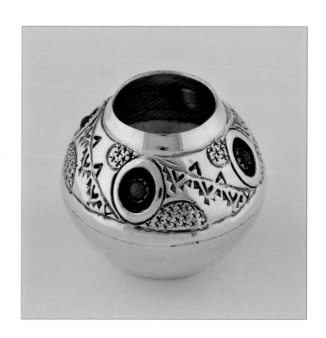

ESTHER WOOD
Navajo, b. 1946

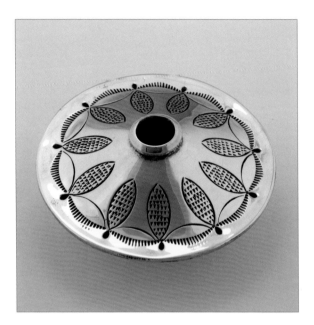

POT
Silver

Wood's silver seed pot has a stylized stamped corn motif. ◼

As a kid, we ate a lot of corn food. We used to plant and do all the fieldwork and then harvest. The corn foods were my favorite next to mutton. I always remember that my mother had a milk cereal made out of blue corn meal in the morning … we all sat down and ate as a family, and that brings me a lot of good memories.

— TIMOTHY BEGAY, NAVAJO (2004)

KEE YAZZIE, JR.
Hopi/Navajo, b. 1969

POT, 1999
Silver

Says Yazzie, "The silver bowl is all one piece, top and bottom. It is see-through, so forming this was a challenge. The designs I used are all related to the stars, to the sun."

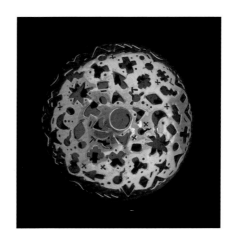

(facing page, clockwise from top left)

POT, 2002
Silver

This silver seed pot is textured with a raindrop design that overlays deeply stamped oxidized linear designs surrounding a star opening. Yazzie uses a Dremel machine to obtain the unique texture.

POT
Silver

Dragonfly designs are stamped on the top half of this pot.

MIGRATION, 2006
Silver, fourteen-karat gold, coral

The theme of migration is represented here by four appliquéd spiral designs and a single fourteen-karat gold star.

POT, c. 2005
Silver

A variety of cutout designs combine to create the visual character seen here. ■

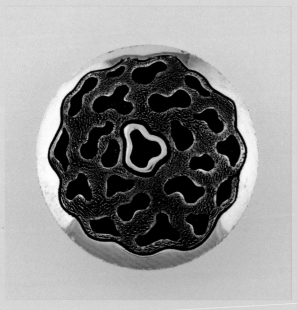
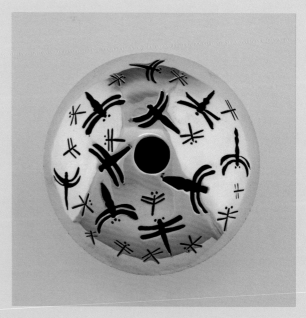
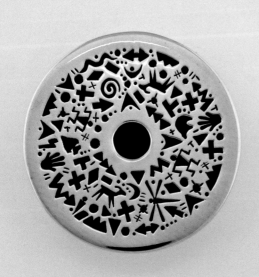
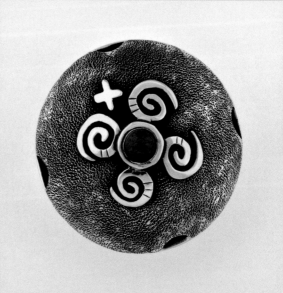

This final group of silver seed pots and bowls in the Sandfield collection cannot be attributed to any specific artist.

 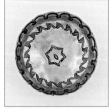 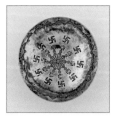 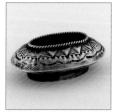 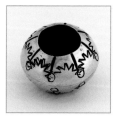 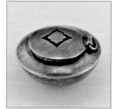

(left to right)

BOWL, 1930s-1940s
Silver

This four-footed vintage oval bowl has stampwork and a twisted wire rim.

BOWL, 1930s-1940s
Silver, copper

This four-footed vintage bowl is stamped with geometric designs.

BOWL, 1930s-1940s
Silver

This vintage three-footed bowl bears stamped whirling log and thunderbird designs.

BOWL, 1930s-1940s
Silver

This vintage oval bowl has a wire-twisted rim with stampwork.

POT, c. 1997
Silver

Eight geometric shapes occupy the top and bottom of this pot.

PILLBOX, c. 1920s-1930s
Silver

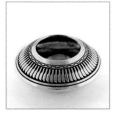 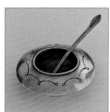 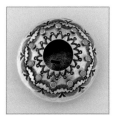 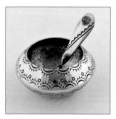 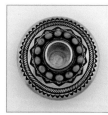

(left to right)

POT, 20th century
Silver

This pot has small feather designs on the top.

BOWL WITH SPOON, 20th century
Silver

This bowl has stampwork and is accompanied by a spoon.

POT, 20th century
Silver, turquoise

This pot has a stamped top and textured bottom. Eleven turquoise stones surround the opening.

BOWL WITH SPOON, 20th century
Silver, turquoise

This silver bowl is accompanied by a twisted-handle spoon with turquoise inlay.

POT, 20th century
Silver, Sleeping Beauty turquoise

The geometric stamped top and bottom of this pot has been further embellished by fourteen Sleeping Beauty turquoise stones set around its opening.

Peru
MINIATURE CUP, 1000 C.E.
Metal

Silver Seed Pot Terminology

There appears to be no "official" recognized terminology for the shapes and functions of American Indian pottery vessels and containers. Writers, dealers, museums, and others appear to use various terms such as pot, bowl, jar, or vase interchangeably, or at least casually, and we have not been able to find an authoritative source upon which to base our terminology. Therefore, for the sake of internal consistency, we have prepared the following definitions for use in this book.

FOOT-RIM OR FOOT RING: a projecting support ring on the underside of the base of a plate or bowl.

LID: a covering for a larger opening vessel, such as a bowl.

LIP: the outer edge of a rim.

MINIATURE: a much-reduced copy of a larger functional piece.

MOUTH: top opening in a round bowl, jar, or vase.

NECK: part between the mouth-rim and shoulder on a jar or a vase.

PLATTER: a saucer or plate.

SEED BOWL: generally, a spherical vessel with a rounded bottom and a very wide top opening. Usually the vessel is shorter than it is wide.

SEED JAR: a vessel with constricted lip opening; the same as a seed pot.

SEED POT: generally, a spherical vessel with a rounded bottom and a very small top opening, most often without a foot ring.

SHOULDER: outward projection of a vase under the neck or mouth.

STOPPER: a small plug inserted into an opening in the top of a vessel, such as a jar.

VASE: a pot taller than it is wide, used for various purposes.

Glossary of Terms

APPLIQUÉ: decoration of one material attached to another.

BEZEL: the groove and flange holding a stone in place.

CROSSCUT-TIP HAMMER TEXTURE. a term coined by Norbert Peshlakai that refers to a specific type of hammered pot texture he creates with a ball peen hammer.

INLAY: to set pieces of stone, wood, etc., into a surface for decoration.

OVERLAY TECHNIQUE: a layer of material such as silver or gold applied over a surface.

PUNCH-TIP HAMMER TEXTURE: a term coined by Norbert Peshlakai that refers to a specific type of hammered pot texture he creates with a punch hammer.

REPOUSSÉ: shaped or decorated with patterns in relief formed by hammering and pressing on the reverse side.

SOLDER: a metal alloy used when melted to join or patch metal parts.

TUFA CAST: a design is carved into a tufa stone, a form of sandstone. The design must be carved into the tufa in the mirror image of what the artist wants the finished piece to look like. Then molten metal is poured into the design. When the silver is cool, the hardened piece is pulled from the cast.

APPLIQUÉ

INLAY

OVERLAY

TUFA CAST

Bibliography

Adair, John. *The Navajo and Pueblo Silversmiths.* Norman: University of Oklahoma Press, 1944.

Baxter, Paula A. *Southwest Silver Jewelry.* Atglen: Schiffer Publishing, 2001.

Bedinger, M. *Indian Silver: Navajo and Pueblo Jewelers.* Albuquerque: University of New Mexico Press, 1973.

Benefield, Karla. "Dream Enemy is a Prize Winner." *The Gallup New Mexico Independent*, Wednesday, 07 June 1978.

Bennet, E.M. *Turquoise and the Indian.* Chicago: The Swallow Press, Inc., 1966.

Cirillo, Dexter. *Southwestern Indian Jewelry.* New York: Abbeville Press, 1992.

Cohen, Lee M. *Art of Clay: Timeless Pottery* of the Southwest. Santa Fe, N.M: Clear Light Publishers, 1993.

Frank, L. with M.J. Holbrook II. *Indian Silver Jewelry of the Southwest, 1868-1930.* West Chester: Schiffer Publishing, 1990.

Interview with Norbert Peshlakai conducted by the author, March 2006, Heard Museum, Phoenix, Arizona.

Interview with Norman L. Sandfield conducted by the author, November 2005, Chicago, Illinois.

Interview with Lorenzo Tafoya conducted by the author, October 2006, Heard Museum, Phoenix, Arizona.

Loscher, Tricia. "Creating and Collecting Culminate in Gift of Silver Seed Pots." *Heard Museum Journal*, Volume 9, No 1, pp 17-19, July-December 2006.

Mathews, Washington. "Navajo Silversmiths," *Second Annual Report of the Bureau of Ethnology of the Secretary of the Smithsonian Institution, 1880-1881*, by J.W. Powell. Washington: Government Printing Office, 1883.

Pardue, Diana F. "Native American Silversmiths in the Southwest." *American Indian Art Magazine*, Summer 2005, pp 62-69.

Pardue, Diana F. *The Cutting Edge: Contemporary Southwestern Jewelry and Metalwork.* Phoenix, AZ: Heard Museum, 1997.

Sandfield, Norman L. *Small Treasures in Silver: Contemporary Miniature Silver Pots by Native American Artists. A Presentation for The Heard Museum Collections Committee*, December 9, 2005. Originally Written September 28, 1998. Unpublished Manuscript.

Schuller, Mary. "Around New Mexico." *Albuquerque Journal*, Sunday, 02 November 1975.

Struever, Martha Hopkins. "Silversmith Norbert Peshlakai, Navajo." *Indian Artist*, Spring 1997, pp 59-63.

Woodward, A. *Navajo Silver: A Brief History of Navajo Silversmithing.* Flagstaff: Northland Press, 1974.

Wright, Margaret N. *Hopi Silver: The History and Hallmarks of Hopi Silversmithing.* Flagstaff, AZ: Northland Press, 1989.

Biographies

TRICIA D. LOSCHER is curator and program director at the Heard Museum North Scottsdale, Arizona. Exhibitions Loscher has curated include *Choices and Change: American Indian Artists in the Southwest*; *Allan Houser: Shadows and Form*; *Mid-Century Modern: Native American Art in Scottsdale*; *75 Years at the Heard Museum*; *Paintings and Poems of T.C. Cannon*; *Metalworks: Containers of Form, Function and Beauty*; *Cultural Colors: Fiber Art and Drawings by Ramona Sakiestewa*; *Of Grasses, Ferns and Trees: California and Great Basin Baskets*; and *Fabric, Wood and Clay: The Diverse World of Navajo Art*. Loscher also plans and implements educational programming such as the annual Heard Museum North Navajo Folk Art Festival, and the Lecture Series. She guest curated an exhibition on the life and art of Arizona artist Kate T. Cory, as part of the Centennial Celebration at the Arizona State Capitol Museum. She subsequently received the Sonnichsen Award for article of the year for "Kate T. Cory: Artist in Hopiland," published by the *Journal of Arizona History*.

Chicagoan **NORMAN L. SANDFIELD** is a internationally known antique dealer who has specialized in fine antique and contemporary Japanese toggles known as *netsuke* for almost thirty years. He has been a collector for all of his personal and professional life, and while most of his personal collecting is eclectic, he has focused on antique and vintage Chinese ceramic puzzle vessels, and his collection of antique and vintage plastic *netsuke* is both unusual and unique in number.

His interest in silver seed pots by American Indian artists began with a purchase of two very small pots by Norbert Peshlakai and continued on a casual basis for years but became a major collecting focus when he realized that he was the lone serious collector in this field. Sandfield's initial relationship with the Heard Museum dates to his loan of silver seed pots for *The Cutting Edge: Contemporary Southwestern Jewelry and Metalwork* in 1997, and the 2003 exhibition *Metalworks: Containers of Form, Function and Beauty*. The success of these loans and exhibitions encouraged his pursuit of and passion for the pots and their artists, as well as strengthened his relationship with the Heard Museum. In addition to Sandfield's gifting of his miniature silver seed pots to the Heard Museum, he has donated and continues to enrich a collection of some 3,300 volumes on *netsuke* and other Japanese art to the Toledo Museum of Art Library. Another 1,000 volumes will be donated in the near future. In both cases, he says that he has absolutely no "donor's regret."

MARTHA H. STRUEVER began collecting American Indian art in 1971. In 1976, she established the Indian Tree Gallery in Chicago, working as its director until it closed in 1983. Over the past thirty years she has given many artists their first gallery shows and has educated numerous new collectors through seminars, lectures, and symposia. For Crow Canyon Archaeological Center, Marti organized nine benefit Indian art shows in Chicago, Washington, D.C., and Denver, Colorado, bringing Indian artists to sell their work at each event. She has guest curated museum exhibitions on the renowned potter Nampeyo at Kendall College, a historical view of Hopi art at the San Francisco Craft and Folk Art Museum, and retrospectives at Santa Fe's Wheelwright Museum of Dextra Quotskuyva's pottery in 2002 and Charles Loloma's jewelry in 2005. She is the author of *Painted Perfection: The Pottery of Dextra Quotskuyva* and *Loloma: Beauty is His Name*, both published by the Wheelwright.

Index